DORSET
AVIATION
THROUGH TIME
Mike Phipp

AMBERLEY

First published 2020

Amberley Publishing
The Hill, Stroud, Gloucestershire, GL5 4EP
www.amberley-books.com

Copyright © Mike Phipp, 2020

The right of Mike Phipp to be identified as the
Author of this work has been asserted in accordance with
the Copyrights, Designs and Patents Act 1988.

ISBN 978 1 4456 9848 9 (print)
ISBN 978 1 4456 9849 6 (ebook)

British Library Cataloguing in Publication Data.
A catalogue record for this book is available from the
British Library.

Typesetting by Aura Technology and Software
Services, India. Printed in Great Britain.

Contents

Introduction

Often overlooked by many people, as they think that Dorset has few aviation connections, this book sets out to show that the county has much to do with aviation. Some of the early events in Bournemouth and Christchurch took place when the towns were still in Hampshire, but they have now been part of Dorset for many years.

The book concentrates on earlier events in the county. The story of the development of Bournemouth Airport and of the local aircraft industry has been covered in my earlier Amberley publications, so don't need repeating here. Dorset has seen a good cross-section of military and civilian aviation over the years, which continues into the 2020s.

My thanks for assistance and for photographs go to Charles Rolls Heritage Trust, Colin Pomeroy, Dave Fagan's Dorset Airfields, Dorset Plane Pull, Bournemouth Aviation Museum, Poole Flying Boat Celebration, Royal Aeronautical Society – Christchurch Branch.

OUR FIRST USE OF THE NEW ARM DURING NAVAL BATTLE-PRACTICE.

DRAWN BY NORMAN WILKINSON, R.I., OUR SPECIAL ARTIST AT WEYMOUTH.

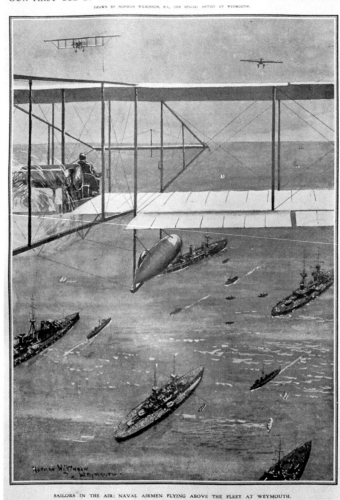

SAILORS IN THE AIR: NAVAL AIRMEN FLYING ABOVE THE FLEET AT WEYMOUTH.

Early Days

Aviation arrived in Dorset in the spring of 1909 with the construction of a biplane at Dorchester by Ernest and Ralph Channon who worked in the family motor works business. In the spring of 1909, the brothers decided to build a Wright-style biplane powered by a White & Poppe engine. This was around the time that the Wright Brothers visited England and Bleriot flew across the English Channel. Later in the year Ralph took the Channon to the slopes of Maiden Castle for flight trials, but these proved unsuccessful. The biplane was fitted with skids which should have run down wooden planks fitted to the slope to build up speed, but it failed to take to the skies. Wheels were fitted for further trials by Ernest the following year but he only managed limited flights. As a result, the brothers decided to stick to the motor business. So Dorset was involved in the earliest days of British aviation and remains so at the present time.

Over at Bournemouth there was a similar garage connection. William McArdle owned Motor Mac's Garage at the Lansdowne and became interested in the new sport of aviation. Again, in the spring of 1909, he built a Bleriot-style monoplane with a Mr Gould of Boscombe, but neither were able to coax it into the air. There was more to flying than they had envisaged. So McArdle travelled to Paris in 1910 to learn to fly at the Bleriot Aviation School, obtaining his Aviators Certificate later in the year. At the school he met a wealthy American businessman – J. Armstrong Drexel – who also wanted to build an aircraft. They decided to return to Bournemouth and at the beginning of 1910 started the construction of a number of Bleriot-style monoplanes. Following successful testing of the first at Talbot Village the partners organised a flying display with four Bleriots over the Whitsun Bank holiday. This was the first chance for locals to see an aircraft and large numbers attended the event. The fields at Talbot Village are now the site of Bournemouth University.

Bournemouth residents didn't have long to wait for their next aviation event. As part of the town's 100th anniversary the Bournemouth International Aviation Meeting was held from 11–16 July 1910 at Southbourne. This was a major coup for the town as it was the first International Aviation Meeting in Great Britain. The gentry arrived by carriage and car, with the public having to travel by corporation tram to nearby Tuckton. The meeting attracted twenty well-known fliers from Britain and the continent, including Samuel Cody, Claude Grahame-White, Charles Rolls, as well as Drexel. They competed for height, speed and distance – where a 10-mile flight to the Isle of Wight and back was considered a feat. The outright winner was Frenchman, Léon Morane, who won £3,425 of the total £8,500 prize money. However, the meeting is remembered for the death of Charles Rolls, on 12 July, when the tail of his Wright biplane broke off and the frail craft provided no protection when it plunged to the ground. In due course a memorial provided by Rolls-Royce commemorated the event and plans are in hand for a more substantial heritage patio.

The Royal Navy were to provide Dorset with its next major aviation event – a review of the Home Fleet by King George V, which took place at Portland in May 1912. The Navy had commenced aircraft trials and had flown a Short biplane from the deck of a battleship moored in the Thames off Sheppey. It was decided to repeat the event in Weymouth Bay for the benefit of the King. A land base was established at Lodmoor, to the east of the town, and a marque-style hangar was erected on the north-east side of Portland. A handful of aircraft were airborne to meet the Fleet as it approached Portland – itself a novelty at the time. HMS *Hibernia* had a launching ramp built on its foredeck on which it carried a Short S38 and an S41. Both aircraft undertook flights from the sea. On 9 May it was intended to display the

aircraft taking off from the ramp in front of the King. However, fog put paid to the plans. Not to be put off, Lt Cdr C. R. Samson, in the Short S38, took off later in the evening when the battleship was steaming at 10.5 knots, making his landing at Lodmoor. His was the first take-off from a moving warship, starting naval aviation as we know it today. For his exploit Samson was invited by the King to join him for dinner on board the Royal Yacht. The Fleet Review brought a number of other aircraft which were based at Lodmoor. Later one of the pilots flew his Bleriot back to Hendon in a then remarkable time of 1 hour forty-five minutes.

During 1912 the *Daily Mail* sponsored a number of fliers to undertake demonstration flights around the country. In July, Jules Fischer arrived at Bournemouth seafront in his Farman hydro-aeroplane to give flights, which included the Mayor and Town Clerk. Fischer then moved to Weymouth before heading off for Exmouth. Henri Salmet in a Bleriot also visited Bournemouth during his 'Grand Aviation Tour of England'. At Sherborne's Conservative Fete in August, demonstrations were given by Herbert Spencer in his Wright-style biplane. Salmet returned to the Bournemouth area in 1913, coming to grief at Tuckton in November when his Bleriot ran into a tree on landing. Undeterred he flew Father Christmas into the town's Meyrick Park so he could make his annual visit to Beales store – it made a change from his usual sleigh. April 1914 saw a demonstration of 'Looping the Loop and Upside-down Flying' by Gustav Hamel at Meyrick Park, Bournemouth. As usual vast crowds attended, witnessing Hamel undertake twenty-one loops in his frail aircraft.

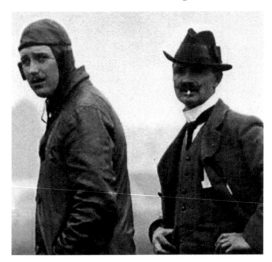

Left: Bournemouth's aviation pioneers were J. Armstrong Drexel and William McArdle, both having learnt to fly in Paris. Drexel looks the part dressed in flying gear, whereas McArdle seems more like he's spending a day at his garage business.

Below: With ground-crew in attendance, McArdle poses in the seat of the Bleriot which had probably been built in his garage at the Lansdowne. Drexel and McArdle had four aircraft available for a flying display at Vines Farm over the 1910 Whitsun bank holiday.

A Bournemouth Motor Dealer becomes Aviator.

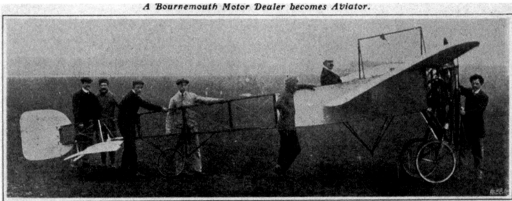

Mr. McArdle in his Bleriot machine ready to start.

Right: Ready for action Drexel seated in one of the Bleriots that the two aviators had built at Bournemouth in 1910. For test flying during April they were taken to a field at Vines Farm, Talbot Woods, to the north of the town.

Below: The other Dorset pioneers were the Channon brothers of Dorchester, who built a Wright-style biplane in 1909, with test flights undertaken from the slopes of Maiden Castle. Here the Channon tries to take-off from wooden rails which were meant to guide its skids.

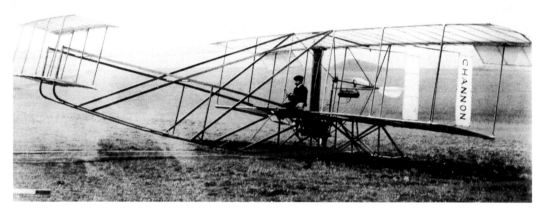

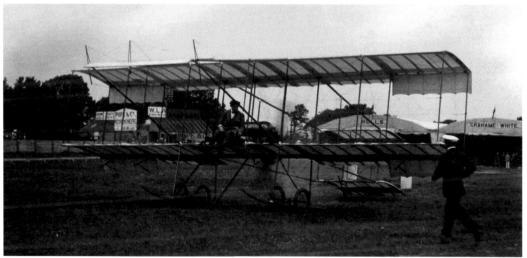

Claude Grahame-White was one of the well-known aviators participating in the July 1910 Bournemouth Aviation Meeting, flying both a Farman biplane (seen here) and a Bleriot monoplane. Each pilot had his personal canvas hangar as seen in the background.

7

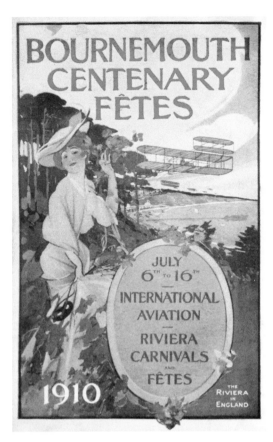

BOURNEMOUTH CENTENARY FÊTES

JULY
6TH TO 16TH
—
INTERNATIONAL
AVIATION
—
RIVIERA
CARNIVALS
AND
FÊTES

1910

THE
RIVIERA
IN
ENGLAND

Left: The Bournemouth Aviation Meeting held at the 'Magnificent Aerodrome' at Southbourne was promoted as the aviation event of the year with prizes totalling £8,500. As part of Bournemouth's Centenary Fete events, this publicity brochure shows a Wright biplane flying over the pine trees and sea front of Bournemouth. In the event only a few aircraft were seen over the town as flying was concentrated at Southbourne – 5 miles to the east.

Below: Part of the crowd who have turned up at Southbourne Aerodrome to discover what flying is all about. The gentry turned up in their cars and paid £1 for a special enclosure. Grahame-White flies past in his Farman, with Christchurch Priory in the distance.

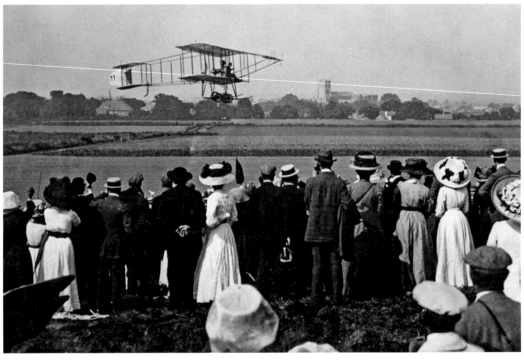

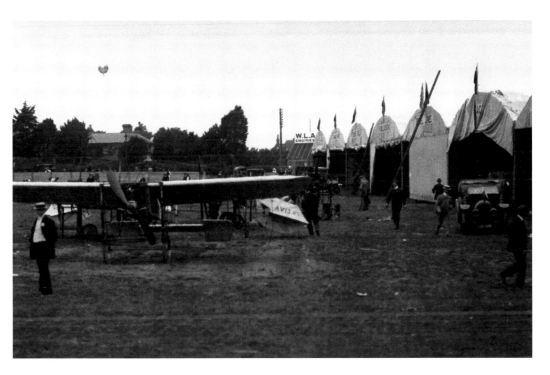

A busy scene in front of the hangars erected at Southbourne – the site of the present-day Broadway and playing fields of St Peters School. There is a Bleriot facing the camera with a smaller Avis behind it. Note the balloon flying overhead.

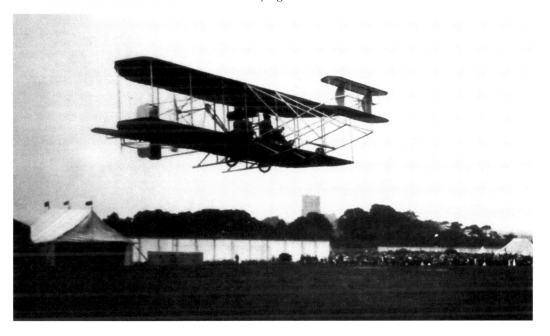

The Hon. Charles Rolls flying his Wright biplane on 12 July 1910. Shortly afterwards the aircraft's tail section broke off during the spot landing competition and Rolls died in the ensuing crash. He was the first British aviator to be killed.

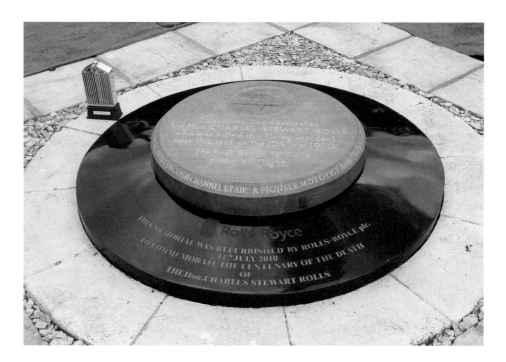

To commemorate Rolls' death on 12 July a stone memorial was later placed within the grounds of St Peters School at the site of the crash. The memorial was refurbished by the Rolls-Royce company in 2010 but unfortunately remains out of public view.

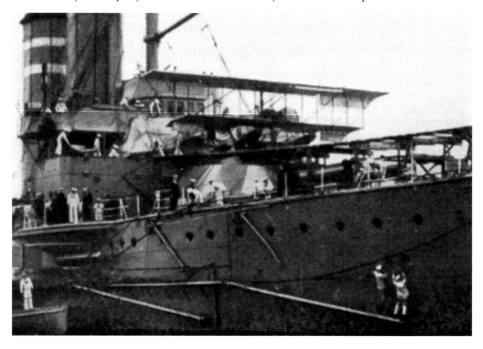

The 1912 Fleet Review in Weymouth Bay gave the Royal Navy the opportunity to demonstrate the first aircraft take-off from a moving warship. Seen perched on the foredeck of HMS *Hibernia* is the Short S38 which made the flight on 8 May.

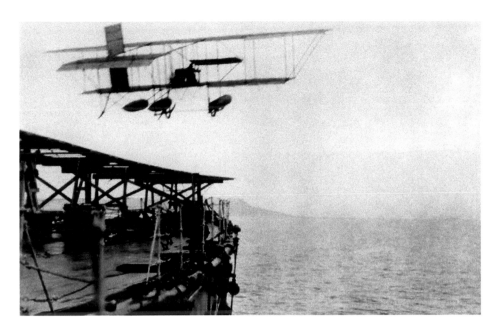

Piloted by Commander Samson, the Short S38 departs the deck of HMS *Hibernia*. Today you could get a similar view of an F-35 Lightning departing the deck of HMS *Queen Elizabeth*. The Short flew on to land at Lodmoor, to the east of Weymouth.

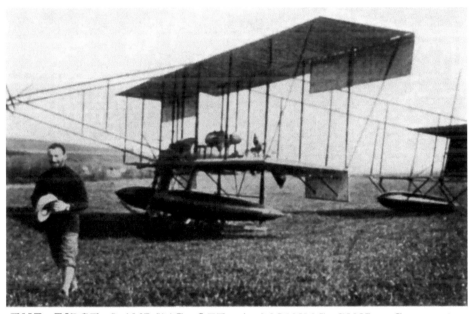

THE FIRST LANDING OFF A MOVING SHIP.—Commander Samson after landing at Lodmoor, near Weymouth, from the platform on H.M.S. Hibernia.

Commander Samson walks away from the Short S38 biplane after landing in a field at Lodmoor. The aircraft had been fitted with floats to enable it to land on water. However, it then had some skids fitted under the floats for landings ashore.

11

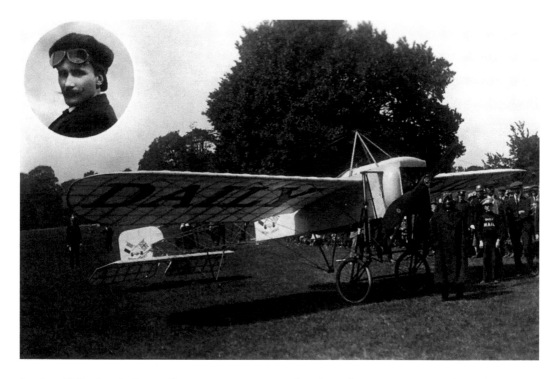

During 1912 the *Daily Mail* newspaper sponsored a 'Grand Aviation Tour of England'. This included a Bleriot XI monoplane flown by Frenchman Henri Salmet, who visited the West Country during July, arriving at Bournemouth the following month.

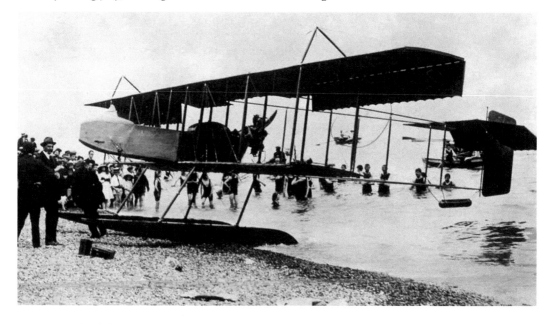

Touring England during the summer of 1912 was Jules Fischler in his Farman 'hydro-aeroplane'. He visited Bournemouth in July, giving flights to the town's Mayor and Town Clerk. Fischler then visited Weymouth to repeat his performance.

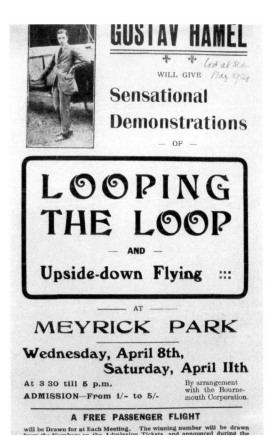

Right: Gustav Hamel was another well-known display pilot who was sponsored by the *Daily Mail*. This poster publicises his visit to Bournemouth in April 1914, during which he undertook an amazing twenty-one loops in his Morane-Saulnier monoplane.

Below: The Bournemouth Aviation Company established a flying school at Talbot Woods in November 1915. The following year sees a line-up of Caudron G IIIs used for training (among others) future pilots for the Royal Flying Corps.

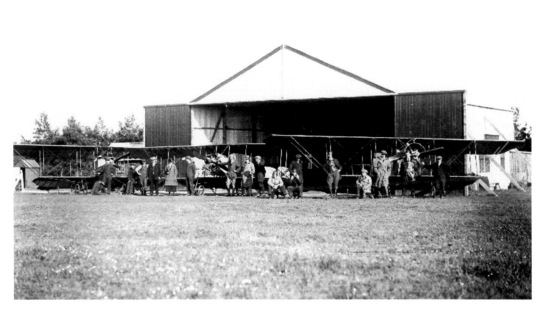

An advert for the Aviation Company showing that it also undertook civilian instruction. Despite being wartime, flights were offered to the public at £3, with spectators being charged 6d or 1/- to view the flying activity.

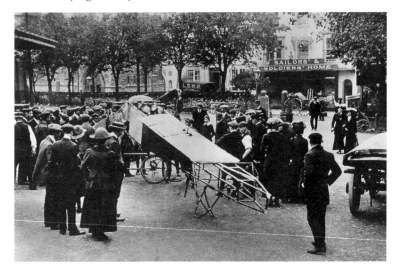

Claude Grahame-White's Farman at Weymouth in May 1912 while en route from the Railway Station to Lodmoor. Here fields adjacent to the Weymouth Cricket Club were taken over by the Royal Navy for flights in connection with the Fleet Review.

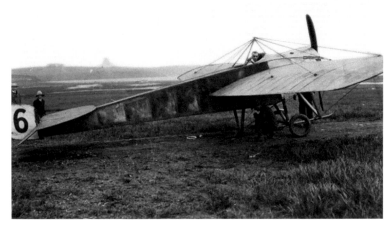

Now at Lodmoor Grahame-White's Farman receives attention, while he remains in the cockpit. He undertook a number of flights over the Home Fleet Review but vast crowds visiting Lodmoor resulted in police being called to regain control.

First World War

Initially the outbreak of war did not have an effect on Dorset, although regulations were introduced in January 1915 preventing the showing of lights at night in case of Zeppelin attacks. The Bournemouth Aviation Company operated a flying training school at Talbot Woods from November 1915. As well as training, flights were available from £3 for the public with spectators charged 1/- to gain entry to the Bournemouth Aerodrome – 'One of the finest private flying schools in England'. The school moved to nearby Ensbury Park early in 1917 where more space was available. The airfield was also used by the Royal Flying Corps, who referred to it as RFC Winton.

To help fund the war people around the country were urged to purchase National War Bonds. In Bridport these were issued through the Bridport Aeroplane Bank during 1918. The aim was to raise £15,000 for six aircraft. In fact, the town raised £69,070 – enough for two RFC squadrons.

As the war progressed there was increased German U-boat activity in the English Channel attacking British shipping. To counter this the Royal Navy established a number of coastal seaplane and airship bases. One was established at Portland in the summer of 1916, equipped with Short 184s to undertake patrols over the Channel. They also used Lake in Poole Harbour, flying from adjacent to the existing Admiralty shipyard. Further expansion saw a field at Chickerell, north-west of Weymouth, taken over by the Navy in 1917, from where DH6s operated anti-submarine patrols. The Navy also expanded its airship bases around the country with two brought into use in Dorset in 1917. These were at Toller Porcorum and Upton, both situated in wooded areas to provide protection. Primitive Type SSZ airships undertook scouting patrols over the English Channel, the crew of three seated in an open gondola under the balloon. Another airship base was built at Moreton, east of Dorchester, but the war ended before it could be brought into use. These local bases were all closed by the spring of 1919.

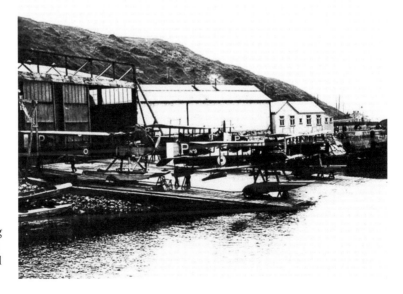

The Royal Navy established a seaplane base at Portland in September 1916 in order to operate patrols over the English Channel. Short 184s were used to search for German U-Boats, from 1917 operating in conjunction with Navy airships based at Toller.

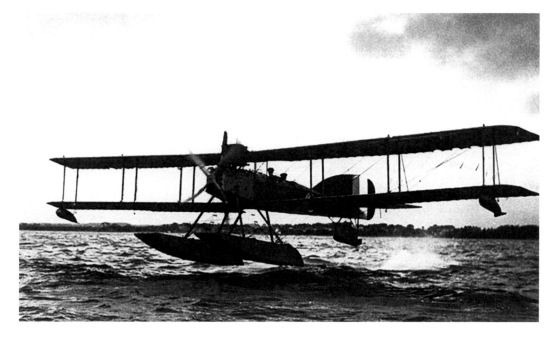

The Portland base was HMS *Sereptia* located close to Castletown. Short 184s float planes were operated by both 416 and 417 flights. In 1918 they also operated from Lake in Poole Harbour, by which time they were part of the new Royal Air Force.

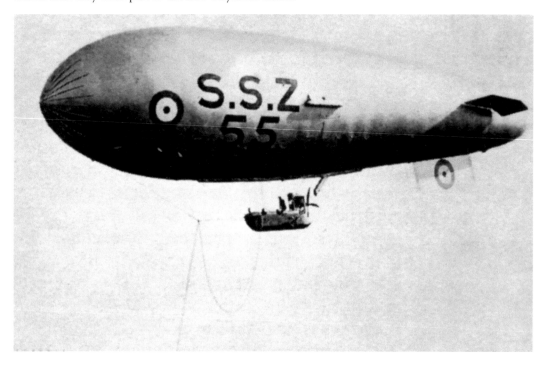

To assist their seaplane patrols the Royal Navy established an airship base at Toller in 1917, followed by one at Upton. Both operated SSZ airships whose crew of three were housed in an under-slung gondola while on the lookout for German U-Boats.

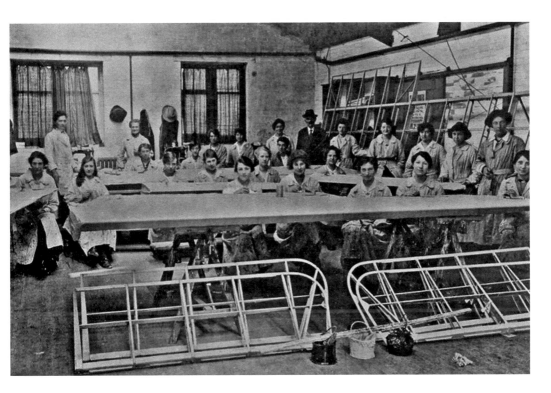

Female workers of the Poole Aviation Company were involved in producing aircraft wings late in the First World War. Based in West Quay Road the company did not survive the return to peace, its works probably becoming part of the town's shipbuilding industry.

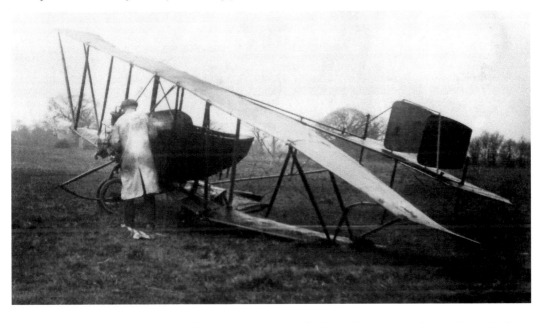

Early in 1917 the Bournemouth Aviation Co. moved a short distance to a larger site at Ensbury Park. Here it claimed to be 'the finest equipped flying school outside of London', although this Caudron has come to grief at the end of its flight.

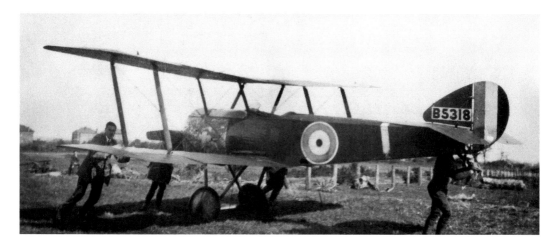

The newly formed RAF also made use of Ensbury Park, naming their establishment RAF Winton. However, it is civilians who are handling this Sopwith Pup. Other RAF types in use included BE2s, DH9s RE8s and Sopwith Camels.

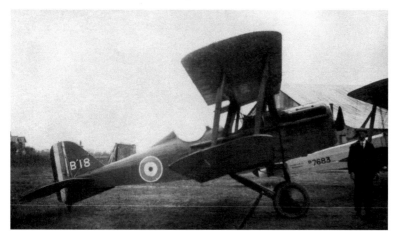

Also at RAF Winton this SE5a fighter was in use during 1918. Behind is an Avro 504K. With the ending of war, the RAF moved their aircraft to Beaulieu in May 1919. However, a number were left behind as the RAF had no further use for them.

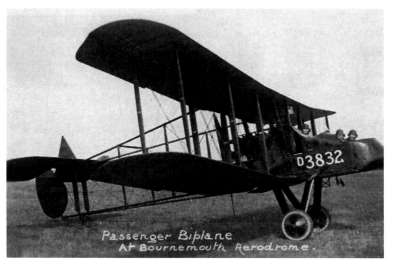

One of the aircraft the RAF left behind at Ensbury Park was this FE2, which was soon commandeered by the Bournemouth Aviation Co. for pleasure flights. The passengers had to be well wrapped up as they occupied the former front gun position.

The 1920s and 1930s

Despite the Armistice being signed in November 1918 it was not until 1 May 1919 that civil aviation was permitted in Britain. In anticipation of this, the Bournemouth Aviation Co. planned flying boat services from the beach at Durley Chine to coastal towns such as Swanage, Lulworth Cove and Weymouth. However, these were never operated, although in July there were limited services by Channel flying boats from Bournemouth Pier to the Isle of Wight. Bournemouth saw its first airline service operate into Ensbury Park from Cricklewood, north London, using converted Handley Page bombers. The first service operated on 9 June with Bournemouth's Mayor and civic leaders flying down from London. Services were also planned to Weymouth, but lack of interest saw the Bournemouth flights end in August, with Weymouth never seeing a service. The site at Lodmoor now had a 730-metre grass runway, plus a canvas hangar, and was registered by the Air Ministry as a licensed airfield. However, there was only sporadic use over the next few years and it was abandoned by the mid-1930s. Flying training as Ensbury Park did not prosper either, with the Bournemouth Aviation Co. giving way to the New Bournemouth Racecourse Ltd at the end of 1921. Horse racing did not prosper either and so the 1926 August bank holiday saw the first of a number of air races. Others followed, which attracted many well-known racing pilots of the time. Races included the strangely named 'Pub Crawl Race' and 'Killjoy Trophy'. However, the 1927 Whitsun Race Meeting was marred by two fatal crashes, which sealed the fate of Ensbury Park as an airfield.

Crowds flocked to Bournemouth seafront on 10 September 1919 to witness the Schneider Trophy Air Race. This was for seaplanes flown over a triangular course in Poole Bay, with entries from France, Italy and Great Britain. The seaplanes were serviced on the beach alongside Bournemouth Pier, with the crowds getting in the way of the mechanics. By lunchtime fog appeared over the bay and the officials decided to delay the race until teatime, but the fog still covered much of the bay. The race turned into a fiasco due to confusion between the organisers, the starting team and the competing pilots. The French were unable to start, leaving it to the Italians and British. The British retired due to the fog leaving it to the Italian Savoia to complete the distance. This it did, but then the officials said it had missed the correct marker buoy off Studland and so the race was declared void. Hardly a satisfactory result for what was anticipated to be a prestigious event.

Burry's Field to the east of Christchurch saw five-shilling pleasure flights undertaken by Avro 504s during the summer of 1928. There were also aerobatic and parachute displays, with spectators charged six pence, although many watched for free from nearby paths! In the spring of 1928, the Hampshire Aero Club set up a base in the adjacent field and this site was developed further. Over in the Purbecks the Worth Matravers football pitch was taken over by the Isle of Purbeck Light Aeroplane Club with an opening flying display held in August 1928. Grandly known as Swanage Aerodrome, it was used by visitors to the local golf club but flying ended in the early 1930s with the field reverting to football. At Weymouth the fields at Chickerell were surveyed by Sir Alan Cobham in August 1929 as a possible site for Weymouth Aerodrome. Although promoted by the Chamber of Commerce, no action was taken by the Town Council to develop the airfield. The Weymouth Gliding Club was formed in the spring of 1930 and initially planned to use Chickerell. The club soon changed its name to the Dorset Gliding Club, settling on a hillside to the north of Maiden Newton as its base. In the early 1930s, anticipating an increase in private flying, the Automobile Association looked after their interests by producing

a Register of Landing Grounds. This showed that Blandford had a field near Pimperne Camp with three grass runways and a hangar; Christchurch had a field to the east of the town which also provided for Bournemouth; Shaftesbury had a field at Cann with a single runway; Dorchester – the County Town – did not appear in the register, neither did Swanage. Dorset was visited on a number of occasions in the 1930s by Sir Alan Cobham with his Flying Circus displays. Cobham was most active between 1933 and 1935, visiting the majority of Dorset's towns – Bournemouth, Bridport, Christchurch, Gillingham, Lyme Regis, Sherborne, Swanage and Wimborne. Sir Alan's aim was to introduce flying to the public by giving flights in one of the circus's airliners. Although air travel did not develop as quickly as he anticipated, the circus did have other benefits. On the outbreak of the Second World War the majority of prospective young new pilots said they had their interest in aviation instilled by Cobham's Flying Circus. After his Flying Circus days Sir Alan went on to develop a system of in-flight refuelling.

The various fields used at Christchurch were combined in 1934 on the setting up of Christchurch Airfield Ltd to provide airline services. These commenced in the spring, with limited services to Bristol, Plymouth and Portsmouth, but were soon suspended due to the unsatisfactory state of the grass runway. Reorganisation saw the formation of Bournemouth Airport Ltd, which upgraded the airfield and reintroduced the airline services that continued until the outbreak of the Second World War. Also established was the Bournemouth Flying Club which trained pilots with its fleet of de Havilland Moths. The locals were not happy that the airport was named after Bournemouth, but the directors felt that the Bournemouth name was more well-known than Christchurch. In parallel with the development of Christchurch plans were made by Bournemouth and Poole councils to develop their own airport. In June 1935 they purchased land at Moortown (to the west of Bear Cross) and started preparing the site. Bournemouth considered the airport should be larger than originally planned, but Poole were not happy with the increased expenditure. As a result, they pulled out of the development in May 1938 leaving Bournemouth unable to proceed on its own, so Christchurch remained as Bournemouth's airport. Here the Flying Club joined the Civil Air Guard Scheme in September 1938 to help speed up the training of prospective RAF pilots.

Weymouth Bay saw another Royal Fleet Review in July 1932 by King George V, the Prince of Wales and Prince George. The two princes were flown by Fairey IIIFs from the deck of HMS Courageous for a closer view. The Prince of Wales returned to Weymouth on 13 July 1933. He was being flown from London in a de Havilland Dragon when it ran into poor weather over the Dorset coast. As a result, the Dragon landed in a field at Swanage with the Prince continuing by road. King George V continued his visits to Weymouth in connection with Home Fleet Reviews. The last was in August 1939 but fog over the bay prevented the review taking place. Unbeknown to many, a few days earlier the airship *Graf Zeppelin* flew eastwards along the Dorset coast on an espionage flight to observe the Fleet Review. It was also tasked with establishing the effectiveness of the new local radar system. The Navy re-established a floatplane base at the Mere, Portland, equipped with Swordfish and Walrus biplanes. They only operated for a short period before moving to the Orkney Islands – well out of the way of any impending conflict.

By the mid-1930s the British Government felt it had to react to the growing threat posed by Hitler, who had taken power in Germany. The Air Ministry's main concern was to provide for the defence of England's east coast. Dorset was considered out of any foreseeable danger and was selected for a RAF training bombing range. Despite objections the Chesil Beach Bombing Range was established early in 1937, extending into a large area of Lyme Bay. Any aircraft using the range would need a landing ground and so the locally situated Chickerell was upgraded. It was soon realised that a larger airfield would

be needed, and this led to the establishment of Woodsford, to the south-east of Dorchester. 1 May saw the formation of an Armament Training Station, which provided a base for aircraft using the range, and maintained a fleet of elderly target-towing aircraft. Fighter aircraft from around the country would undertake training courses at Woodsford to hone their skills. Any bombers making use of the range usually operated from their home airfield. In July 1938 the airfield was renamed RAF Warmwell to avoid confusion with an existing airfield at Woodford, Manchester. A second bombing range to the south-west of Lyme Bay was also established, being mainly used by trials aircraft operating from Boscombe Down. RAF marine craft were needed to patrol the ranges and check on the safety of the various targets. This led to the establishment of RAF Lyme Regis in 1937 with its launches moored in the harbour.

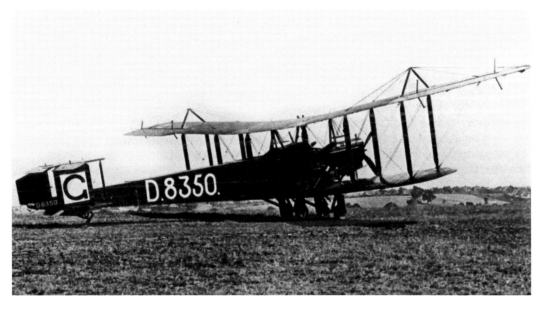

In May 1919 attempts were made by Bournemouth Aviation to establish a service between Cricklewood, North London, and Bournemouth using converted Handley Page 0/400 bombers. Unfulfilled plans were also made to extend the service to Weymouth.

While at Ensbury Park in 1919 one of the HP 0/400s undertook pleasure flights around the town and over Poole Bay. Afterwards passengers were given a memento of their flight, in this case from a New Zealander who was a former RAF pilot.

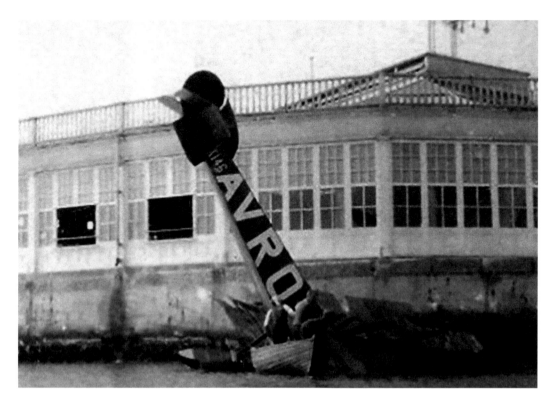

Problems for an Avro 504K floatplane which visited Weymouth in August 1919. It came to grief while taking-off for Bournemouth, ending up in this undignified pose by Weymouth Pavilion. Fishermen swiftly rescued the pilot and passenger.

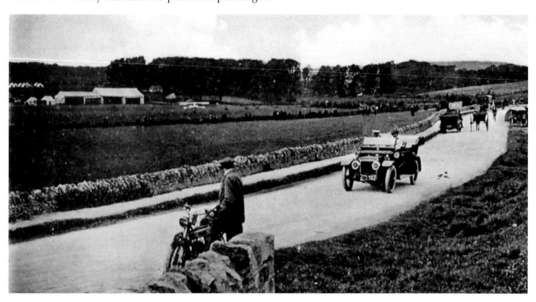

A view of the 'New Weymouth' airfield at Lodmoor in the 1920s, where canvas hangars have been erected on the northern side for visiting aircraft. In the foreground is the road from Weymouth to Osmington, with cars of the period passing.

This Avro 536 (a converted Avro 504) has attracted attention while visiting Lodmoor from Croydon in the summer of 1927. It is probably offering pleasure flights to local holidaymakers, although the attention of the policeman is unexplained.

A closer view of the canvas hangars in 1928 with an Avro 504K in front. The airfield was not used as much as had been hoped, there being little activity by the late 1920s although it was listed by the Air Ministry as an Emergency Landing Ground.

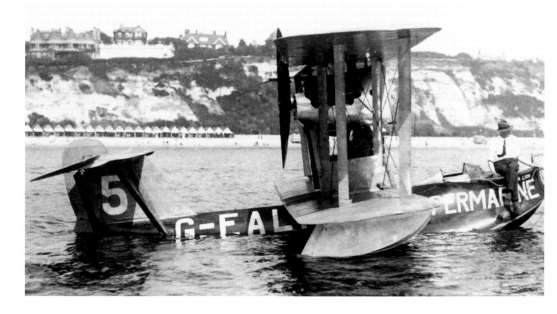

In September 1919 Bournemouth was the venue for the Schneider Trophy Air Race, which was for racing seaplanes, although this Supermarine Sea Lion seems rather cumbersome for a racer. The event was ruined by fog descending over Poole Bay.

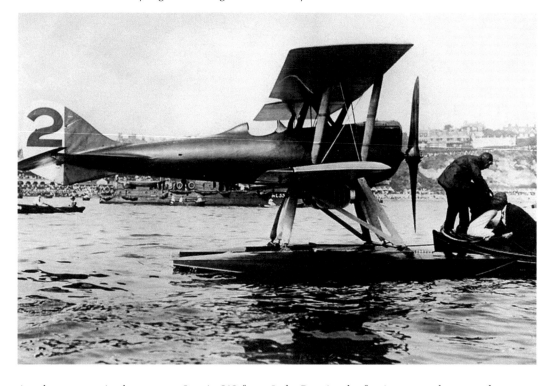

Another entrant in the race – a Savoia S13 from Italy. Despite the fog it managed to complete the triangular course, only to be disqualified for cutting a corner. After objections the Savoia was declared the winner although the race was then declared void.

This Westland Walrus has come to grief in Weymouth Bay in June 1924. Many local pleasure boats were soon in attendance to rescue the crew and try and save the aircraft. Greenhill Beach and St John's Church are in the background.

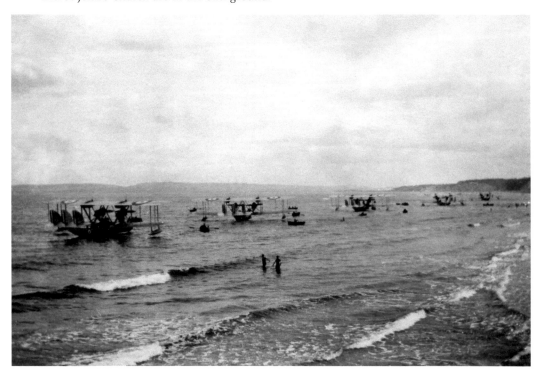

During the 1920s the RAF frequently undertook goodwill visits around Great Britain. Here a flight of Supermarine Southamptons have moored up to the west of Bournemouth Pier during a visit to the town in the summer of 1926.

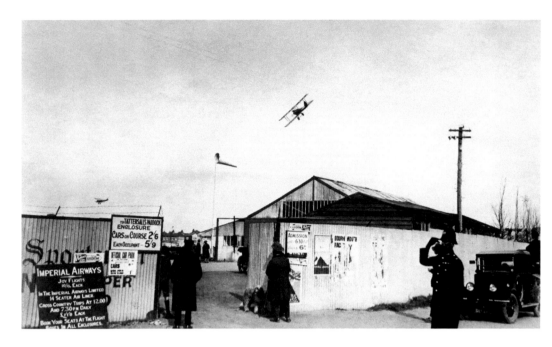

Ensbury Park airfield hosted horse races in the 1920s, hence the Tattersall's Paddock. It was also used for air races. This view is the 1927 Easter Meeting. The Whitsun Meeting saw a number of fatal crashes which resulted in the airfield being declared unsafe.

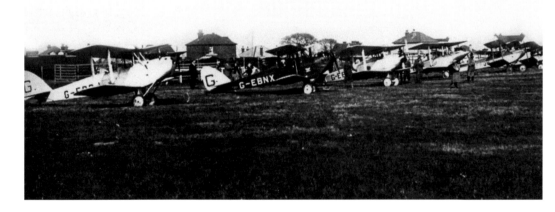

Starting line-up for one of the 1927 races, which attracted a number of well known flyers. One was Bert Hinkler, who gained fame the following year when he flew his Avro Avian solo to Australia.

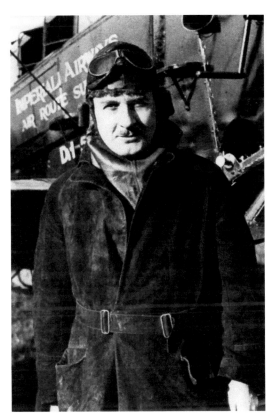
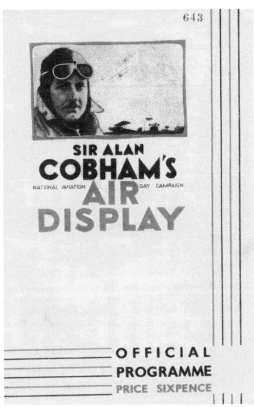

Above left: Sir Alan Cobham was already a well-known name in the country when he started his Municipal Aerodrome campaign in 1929. Touring the south during the summer, he visited Dorchester, Weymouth and Bournemouth to assess possible airport locations.

Above right: Cobham established his National Aviation Day Campaign in 1931 when he toured the country to give the public a taste of flying. They soon referred to it as Cobham's Flying Circus, which visited all Dorset's major towns during 1931–33.

At his Flying Circus displays Cobham gave the public the chance to have a flight in his DH61 *Youth of Britain*. He later used two Airspeed Ferry aircraft which were cheaper to operate. As a result, many people were able to take to the air for the first time.

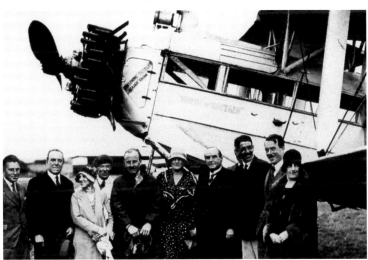

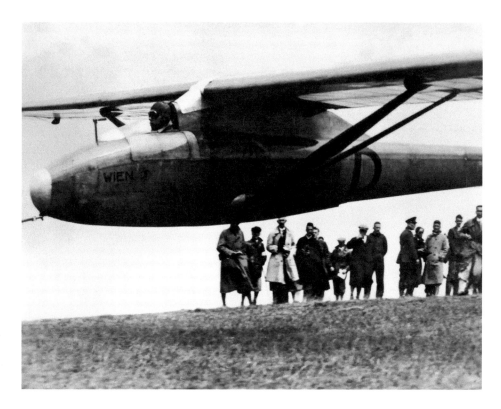

A display was laid on by the Dorset Gliding Club at Askerswell in July 1930. This was mainly so that Austrian pilot Robert Kronfeld could demonstrate his Wien soaring glider. The club eventually settled on the hillside north-east of Maiden Newton for its base.

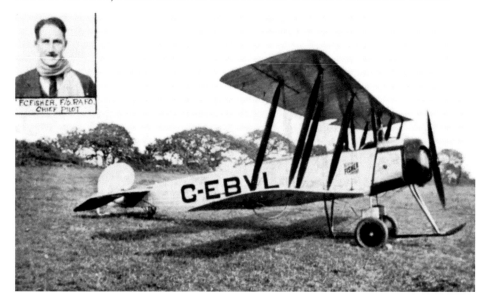

Captain Francis Fisher arrived at Christchurch in the summer of 1930 and offered pleasure flights in his Avro 504K for five shillings. Operating from a site close to Somerford Bridge, he initially slept in a tent by his aircraft and traded as Fisher Aviation.

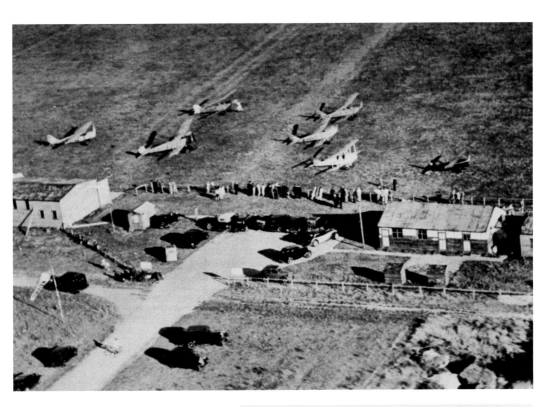

Above: Bournemouth Airport Ltd was established in 1935 to run the now expanded airfield at Christchurch. Airline services soon appeared, and a wooden terminal building was erected on the north side. Plans for an Art Deco style terminal came to nothing.

Right: Sir Alan Cobham was also involved in operations at Christchurch as in 1935 his Cobham Air Routes operated a short-lived service between Croydon, Christchurch and Guernsey. Sir Alan was also one of the directors of Bournemouth Airport Ltd.

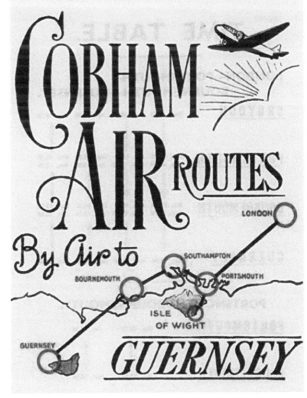

COBHAM AIR ROUTES

By Air to

GUERNSEY

The grandly named Portsmouth, Southsea & Isle of Wight Aviation Co. operated services from Christchurch with aircraft such as this Airspeed Envoy. A number of other airlines operated services from the airfield until the outbreak of the Second World War.

With the threat of war looming the airfield at Chickerell was expanded in 1937 to accommodate aircraft using the newly established Chesil Beach Bombing Range. Seen here are Westland Wapitiis which were used to tow targets for trainee gunners.

RAF Warmwell was established in 1937 as a training airfield mainly for aircraft using the new Chesil Bombing Range. A large hangar was provided and among the aircraft seen are an Anson and various biplane Hinds and Wallaces.

Second World War

Prior to the Second World War passenger services were operated from Southampton to South Africa, Singapore and Sydney by Empire flying boats. It was felt that Southampton would be a German target and that the services should move elsewhere, with Poole surveyed during 1938. With arrangements in place the flying boats arrived in the harbour a couple of days before war was declared. BOAC set up a local HQ in the high street and continued their services. There were also a few trial transatlantic flights to Montreal and New York during September 1939 for the carriage of the Royal Mail. These made use of Sir Alan Cobham's system of flight refuelling. With the fall of France in May 1940 BOAC services had to be rerouted via Lisbon and Gibraltar, then abandoned a few weeks later with the entry of Italy into the war.

The declaration of war on 3 September 1939 did not have an immediate effect on Dorset, with Germany seeming a long way off. There were now more military establishments within the county than at the start of the First World War but none of them seemed under direct threat. This was all to change when Germany overran the Netherlands, Belgium and much of Northern France in May 1940. The Luftwaffe was now able to operate from airfields around the Cherbourg peninsular, bringing them within easy reach of targets in Southern England. The RAF needed to provide additional fighter cover as soon as possible and Warmwell was in the right place. From July 1940 it became a forward landing ground for Hurricanes and Spitfires based at Middle Wallop near Andover, with the fighters thrown into the Battle of Britain. However, there was insufficient accommodation for the crews, with many pilots having to sleep in tents. 31 May saw a visit by Winston Churchill en route to emergency talks in beleaguered Paris, with his aircraft escorted by a flight of local Hurricanes. Dorset received its first Luftwaffe visit on 30 June when Junkers Stukas attacked Portland with little success, with Bournemouth attacked on 2/3 July, again with little damage. Naturally these attacks caused concern among the population as they had never experienced anything like this before.

More serious was the early morning attack on Portland Naval Base by over twenty Junkers Ju.88 bombers on 4 July. As the battle progressed the RAF pilots found themselves up against Luftwaffe formations of 200-plus aircraft, mainly Messerschmitt 109 and 110 fighters that provided escorts for the slower Dornier, Heinkel and Junkers bombers. Midday on 11 July saw attacks on Portland by fifty Stukas and Messerschmitt 110s. The RAF underestimated the force and sent a flight of Hurricanes to intercept the Germans. The ensuing battle resulted in a Messerschmitt 110 crash landing at Tyneham, its crew were the first Germans captured in Britain. Another crashed on Portland Bill, its pilot being a nephew of Hermann Goering. Attacks on Portland and shipping in the English Channel continued with aircraft of both sides shot down, many of the crews having to be rescued from the sea by the Navy or RAF launches. The RAF now based rescue craft at its Lyme Regis marine base, and these saved many lives.

August 1940 saw an increase in Luftwaffe activity prior to the anticipated invasion of England. 'Eagle Day' 13 August was the day the RAF would be defeated, but poor German planning led to its failure. There was an attack on Portland, but the bombers failed to find their target, leaving their Messerschmitt escorts to reach the area. Here Hurricanes were waiting for them, with six enemy aircraft downed in just five minutes. Later Spitfires brought down a further eight Luftwaffe aircraft in the local area. Unable to gain air

superiority, the planned German invasion did not take place and a relaxing of Luftwaffe attacks brought an end to the Battle of Britain in October. The Luftwaffe now turned its attention to bombing important industrial targets. For Dorset this meant bombers overflying the county en route to areas such as the Midlands, Cardiff and Bristol. One tragic outcome was the attack on Sherborne, on 30 September 1940, by forty-three Heinkel 111 bombers resulting in civilian deaths and substantial devastation. The bombers target had been the Westland Aircraft works at Yeovil, but they had been chased away by defending Hurricanes and dropped their bombs as they tried to escape.

To help encourage public moral the Air Ministry introduced the 'Buy a Spitfire Fund' scheme in the summer of 1940 where people raised money to buy a fighter. £5,000 was set as the target to fund an aircraft and there was rivalry between local towns. Poole raised sufficient funds resulting in a Spitfire being named *Villae de Poole*; Blandford subscribed to *Who's a Fear'd* (the County motto), West Dorset provided *The Brit* (Bridport's river), but they were overtaken by Bournemouth who's townspeople raised sufficient for *Bournemouth I* and *Bournemouth II*. As part of the fundraising campaign there was frequently a crashed Luftwaffe aircraft on display. A Dornier 17 was on show at Dean Park, Bournemouth, in September, which could be viewed for six pence. Poole had a Messerschmitt 109 in Poole Park, with another displayed at the Gas Works Sports Ground at Branksome with only three pence being charged. Local schoolchildren frequently found them a source of souvenirs, with parachute remains making useful handkerchiefs.

During 1939/40 a factory was built on the north side of Christchurch Airfield. Run by Airspeed Aircraft it undertook production of Oxford trainers for the RAF, the first rolling off the production line in March 1941. From the summer of 1942 Horsa assault gliders were also produced at Christchurch. VIPs visited the airfield in July 1941 to judge the effectiveness of camouflaging of the site and the Airspeed factory. This would appear to have been satisfactory as the pilot of a visiting Hampden considered the visible landing area too short and flew away. An unexpected arrival on 30 April 1941 was a Luftwaffe Jungmann trainer, which had been flown across the English Channel by two Frenchmen. They were fleeing the Germans and wanted to join the Free French Air Force. However, their arrival caused some embarrassment to the RAF as they had managed to cross the Channel undetected, not causing any concern until they stopped in front of the hangars at Christchurch.

The Battle of Britain had shown the lack of airfields along the South Coast and the autumn of 1940 saw work commence on RAF Hurn. Opened on 1 August 1941, it was initially home to aircraft of the Telecommunications Flying Unit. The unit was involved in the development of radar and had a variety of aircraft ranging from an ancient Gladiator biplane fighter to the latest Halifax bomber. In May 1942 the unit moved to Defford, Worcestershire, to be further away from the coast and any possible German attack. In January 1942 the Air Ministry made a decision that would set Hurn's future as an airport, although it was not realised at the time. The airfield became an additional base for BOAC which operated infrequent services to North Africa with Liberator transports. These got off to a bad start when, on 15 February, one of the Liberators was shot down in error by a Spitfire south of Plymouth while returning from the first Cairo service. Unfortunately, this was a familiar situation in time of war. Hurn was also used by RAF Liberator transports on flights to Egypt and the Near East. The Liberator's long range was vital as the flights had to operate via Lisbon before flying east over the Mediterranean.

Poole Harbour saw the arrival of the Royal Navy in May 1940 when it established a seaplane training base on the harbour side of Sandbanks peninsular. HMS *Daedalus II* was equipped with a mixture of Kingfisher, Swordfish and Walrus, continuing operation until October 1943. BOAC operations continued from the harbour providing services for VIPs and Military 'Brass'.

Three Boeing 314 Clipper flying boats were acquired in May 1941, their long range enabling services to be maintained to West Africa – a vital route at the time. Services were also flown to Foynes in neutral Ireland to connect with Pan American flying boats services from New York. To boost their fleet BOAC received the first of a number of Sunderlands in January 1943, initially used to Lagos and then Karachi. The RAF also arrived at the harbour, establishing RAF Hamworthy in August 1942 with Sunderlands arriving to undertake vital long-range patrols over the Bay of Biscay. This was an area where German U-Boats were sinking vast amounts of Allied shipping without fear of attack. Catalinas replaced the Sunderlands and these continued the Biscay patrols as well as further out into the Atlantic. A gradual build-up of patrols by Sunderlands, Catalinas and Liberators eventually helped to make the Bay of Biscay a safer area. With the reduction of U-Boat operations during the summer of 1943 there was less need for airborne patrols, so the Catalinas departed from Hamworthy in December. The RAF moved out of their Hamworthy base shortly afterwards, the site taken over for D-Day planning.

Bournemouth was selected as a RAF Personnel Reception and Training Centre in 1941. Many halls and the majority of the town's hotels were commandeered for use by hundreds of Australian, Canadian and New Zealand personnel who had arrived in this county prior to being posted to an operational squadron. Among the activities was dinghy training in the Pier Approach Baths. The Centre was visited by King George VI and Queen Elizabeth in October 1941.

Following the Battle of Britain there was a slight lull at Warmwell until the summer of 1942 when it returned to an offensive role. It became the base of Typhoon and Whirlwind fighter bombers, which were tasked with attacking targets in northern France in retaliation for Luftwaffe hit and run raids along the south coast. The Typhoons also undertook long-range patrols over the Bay of Biscay for which they had to be fitted with additional fuel tanks. Warmwell was also the base for early Bouncing Bomb trials for eventual use by the Dam Busters. A Wellington bomber fitted with a scale bomb flew over Chesil Beach in January 1943 dropping various bombs to test the theory of Barnes Wallis – the bomb's designer. Having proved that the idea would work, further trials with a Lancaster took place off the Kent coast at the beginning of May 1943, prior to 617 Squadron's attack on the German dams later in the month.

The Americans set up base at Hurn in October 1942 as part of the preparation for 'Operation Torch' – the Allied invasion of North Africa. Hurn was the British end of the supply line to North Africa, with many troops flown out over the following weeks. Over 100 C-47 Skytrains were used, with many B-17 Fortress and B-24 Liberator bombers also pressed into service as transports. Two VIPs involved were General Ike Eisenhower and Major General Jimmy Doolittle, who flew out of Hurn in separate B-17s. The pilot of Eisenhower's aircraft was Paul Tibbets, who, in 1945, was the pilot of the B-29 *Enola Gay* that dropped the atom bomb on Hiroshima.

The end of 1942 saw the RAF return to Hurn and its use by Airborne Forces for glider training. This mainly involved Horsa gliders, many of which arrived from the nearby Airspeed factory at Christchurch. There were many training exercises where the gliders were towed to locations around Salisbury Plain for mass landings. The gliders were then retrieved for return to Hurn, although many remained littered around the Dorset countryside. One came down at Throop – just short of Hurn. A local schoolboy took charge of the abandoned glider and charged his pals three pence to have a look inside. The Horsas were required for 'Operation Beggar' – the Allied invasion of Sicily. It was decided that the gliders would be flown out to North Africa via Gibraltar, not taken by sea as this would have taken too long. To check the feasibility of the plan a Halifax tug took off from

Holmsley South with a Horsa for delivery to Hurn, which was 5 miles as the crow flies. But the combination took ten hours having flown 1,400 miles on an around the county flight. Large numbers of Horsas towed by Halifaxes successfully reached Gibraltar, the crews showing they could stand the strain of such long-distance flights.

Dorset saw another new airfield with the construction of Tarrant Rushton on hilltops to the south of Blandford during the winter of 1942–43. This was for use by Airborne Forces Units during the planned invasion of Europe, becoming operational in September 1943. The Airborne Forces were to use troop-carrying gliders and the first of a large number of Horsas and Hamilcars arrived in November. The Horsas could carry twenty-five fully equipped soldiers and the Hamilcar could carry vehicles, including light tanks; all very useful for an attack. Converted Halifax and Stirling bombers were used as tugs. There was a great deal of training involving mass take-off and landings with the gliders again frequently ending up in fields around the county instead of back at the airfield.

Around Dorset 'Wings for Victory' weeks were held from 1943 to raise further funds for the war effort. Dorchester had a Hurricane on display in July with £308,000 raised. Set a target of £50,000, the residents of Sturminster Newton raised £127,140, which they were told would cover the cost of twenty-five Spitfires. Bournemouth, being much larger, was able to raise over £2 million – enough for six Sunderland flying boats, three squadrons of four-engined bombers, three squadrons of twin-engined bombers and three squadrons of fifteen fighters! This unlikely total was all part of wartime propaganda. The Minister of Aircraft Production presented the various town with certificates of thanks which were usually displayed within their town halls.

The Luftwaffe was not the only enemy in Dorset. On 26 May 1943 a flight of Mustangs was outbound from Thruxton en route to France. On reaching the Purbecks they encountered fog with the three leading aircraft crashing into Smedmore Hill near Kimmeridge. The remaining aircraft managed to pull up and return to base. A similar incident happened on 15 June 1945 involving a RAF Liberator transport. It had taken off from Holmsley South, bound for North Africa. Shortly after crossing the coast the aircraft encountered problems and the pilot decided to return to base. Bad weather at the time resulted in it crashing into the Purbecks at Encombe (not far from the Mustang's crash site) with all twenty-seven on board killed. This remains the county's worst air disaster.

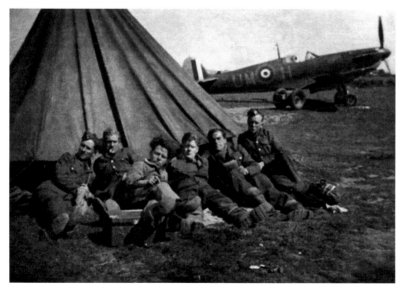

With the outbreak of war RAF Warmwell found itself a frontline fighter base during the Battle of Britain in the summer of 1940. Here crews of 152 Squadron rest outside their tent (there was little permanent accommodation) with a Spitfire behind.

A further view during the Battle of Britain where it looks as though there has just been an attack on the grass airfield. The base's Hurricanes and Spitfires fought many battles over the English Channel with Luftwaffe fighters and bombers.

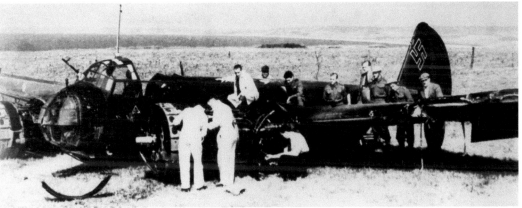

RAF fighter successes included this Junkers Ju88, which came down near Blackmore Fort, on Portland Bill, on 1 August 1940 following an attack by Hurricanes. RAF boffins were pleased to get their hands on this relatively intact bomber.

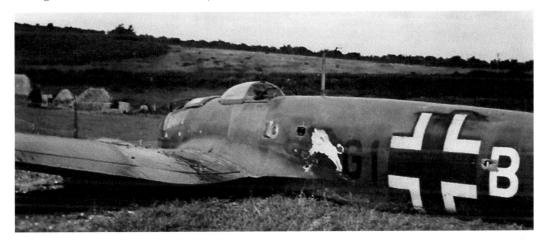

Another Luftwaffe loss was this Heinkel 111 bomber which was brought down near Studland on 25 September 1940, again by Hurricanes. It was one of many Luftwaffe aircraft involved in a bombing raid on the Bristol Aircraft factory at Filton.

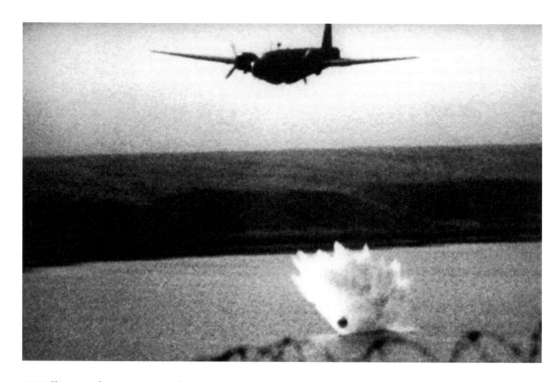

A Wellington dropping an early Bouncing Bomb in The Fleet, adjacent to Chesil Beach during January 1943. Developed by Barnes Wallis, further testing resulted in the Bouncing Bomb used by 617 Squadron for their attacks on German dams.

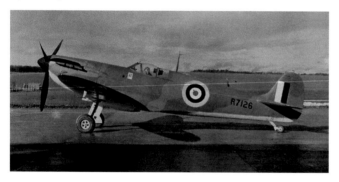

The Government established the 'Buy a Spitfire Fund' campaign, where towns all over the country collected funds to buy a Spitfire. Successful Dorset towns had Spitfires specially named to mark their efforts – this is Poole's *Villae de Poole.*

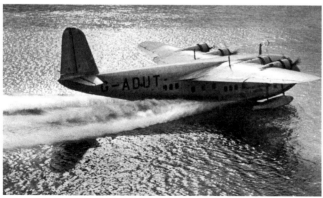

Poole Harbour saw the arrival of flying boats in September 1939 to continue services to the Empire. These were operated by the aptly named Empire Class flying boats, with BOAC establishing a number of offices around the town.

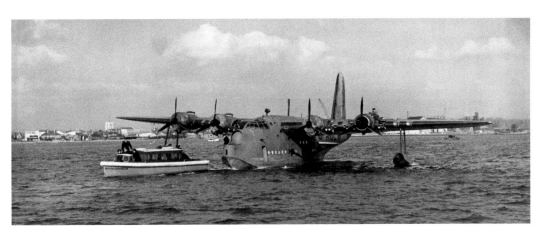

BOAC aircraft were soon camouflaged. Most of the Empire flying boats were transferred to South Africa to continue services to India and Australia. As replacements, BOAC received Sunderlands from 1943. Old town Poole is in the background.

BOAC acquired three Boeing 314 Clippers in May 1941 which were initially used on vital services to West Africa. This publicity photo at Poole shows the use made by the airline of sea women as most of the men were away at war.

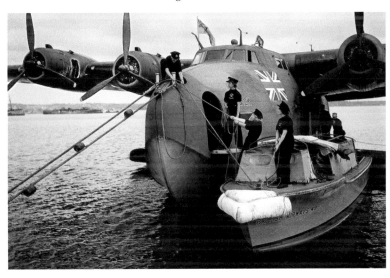

The RAF also made use of Poole Harbour from September 1942, using Sunderlands on anti-submarine patrols over the Bay of Biscay. Operating from RAF Hamworthy at Lake, the Sunderlands were replaced by Catalinas the following April.

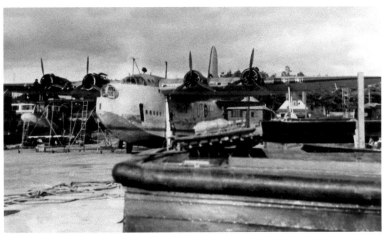

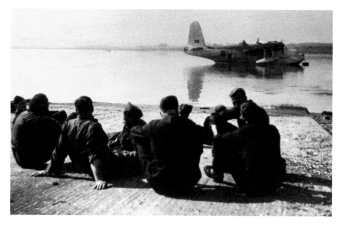

Crews take a break on the slipway of RAF Hamworthy during 1942. There were limited facilities at the base and no cover for the flying boats, with local housing taken over for accommodation. The site remains in use by Royal Marines in the 2020s.

The Royal Navy established a seaplane training base at Sandbanks in May 1940, taking over the premises of the Royal Motor Yacht Club. HMS *Daedalus II* operated a variety of Kingfisher (seen here), Swordfish and Walrus aircraft.

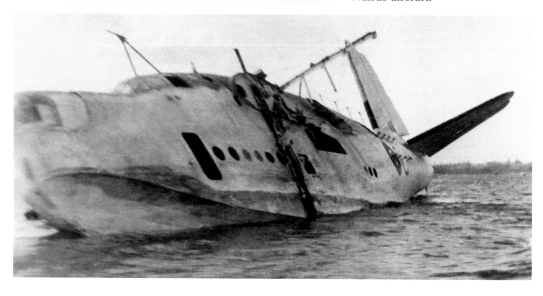

The Sunderland's crews were not impressed with Poole Harbour, where shallow water hindered operations and they were unimpressed with cramped conditions at the base. This 461 Sqd. Sunderland came to grief during its take-off in March 1943.

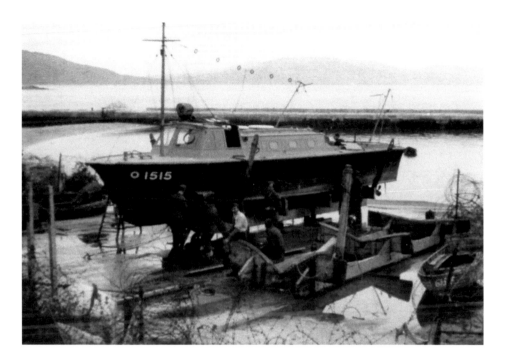

Lyme Regis was the base for RAF marine craft from 1938. Initially operating in connection with the nearby Chesil Beach Bombing Range, it then became home to a number of air-sea rescue launches. D-Day proved a busy time for the unit.

RAF Hurn opened in August 1941 equipped with three runways and many aircraft hard standings. This 1944 view shows much construction work being undertaken on the northern side in preparation for handling more fighters over D-Day.

Early users of Hurn were Mustang Is, which were used on tactical reconnaissance flights over Northern France. They were part of Army Co-Operational Command which was also heavily involved in paratroop training and glider towing.

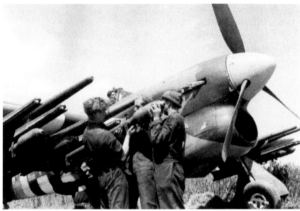

Typhoon fighter bombers moved into Hurn for D-Day – including three Canadian Squadrons. Their mission was to disable the German radar system in northern France so that the approaching invasion forces could not be detected.

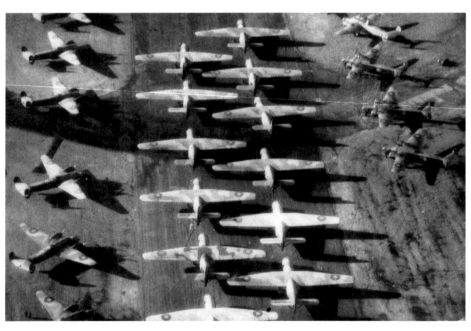

Hurn's runway occupied by Airspeed Horsa assault gliders, with their Albemarle tugs either side. Training flights in preparation for D-Day were undertaken during 1943, the gliders frequently being towed to landing sites on Salisbury Plain.

D-Day

In preparation for the planned invasion Dorset saw a vast number of American soldiers arrive from 1943 with their equipment. These included squadrons of USAAF P-38 Lightnings at Warmwell and P-47 Thunderbolts at Christchurch. The 474th Fighter Group arrived at Warmwell in March 1944, initially undertaking ground attack sorties over northern France. The twin boom and tail design of the P-38 made it instantly recognisable. At Christchurch the Americans felt the need to lay a new runway to cope with their heavy fighters, with the 405th Fighter Group also arriving in March. The crews were accommodated in tents with the officers in nearby Hoburne House. Their P-47s undertook training with other Fighter Groups in the south, eventually having over seventy aircraft. Like the P-38s they undertook ground attack sorties. There were changes at Hurn where the Horsa gliders moved out to be replaced in the spring of 1944 by RAF Typhoon fighter-bombers.

The activities around Dorset were all in preparation for D-Day – the Allied invasion of Europe – on the 6 June. At 9 a.m. the BBC reported 'Allied Naval Forces had begun landing armies on the north coast of France'. All the Dorset airfields were to play their part.

First into action was Tarrant Rushton where all the glider training paid off. On the eve of D-Day six Halifaxes took off late in the evening, towing six Horsa gliders carrying soldiers tasked with capturing vital bridges in Normandy during darkness. The mission was successful, resulting in the taking of what became known as Pegasus Bridge. Other gliders followed carrying troops and equipment into action with resupply flights to Normandy taking place over the next few weeks. Tarrant Rushton was also used by the Americans who flew back injured troops to the nearby US Army Hospitals at Blandford and Kingston Lacy. At Hurn the resident Canadian Typhoon Squadrons were airborne early to reach the Normandy beaches as the Allied troop began their landings. Using a mixture of bombs and rockets they disrupted German movements. Within a few days the Typhoons were able to operate from landing strips prepared for them on the Normandy coast. The USAAF P-47 Thunderbolts at Christchurch found little opposition on D-Day, spending the majority of their time on essential patrols over Brest and the English Channel. Their operations saw Christchurch's worst disaster of the war. One of the P-47s crashed on take-off on 29 June, but the pilot escaped. He took off again in the afternoon, but this time came down on two bungalows at the end of the runway. The explosion brought down a second P-47 and the resulting bomb detonations resulted in the death of sixteen civilians and service personnel. As with Hurn's Typhoons, the P-47s moved to Normandy by the end of June. At Warmwell the P-38 Lightnings provided patrols over the battle zone, continuing these over the next few days. Action came on 18 July when they encountered twenty-five Focke Wulf 190s over Normandy, claiming ten brought down for the loss of only one of their aircraft. Due to their low-level operations, over twenty of the Group's P-38s were lost to ground fire; P-47s proved more resilient in such circumstances. After undertaking over 100 operations the 474th Fighter Group moved to Normandy at the beginning of August and Warmwell returned to its training role. It hosted various RAF fighter squadrons for training on the Chesil Beach ranges until October 1945 when the airfield closed.

Hurn saw USAAF P-61 Black Widow night fighters which undertook operations in July 1944 in conjunction with RAF Mosquitoes. However, they were replaced in August by B-26 Marauder bombers that undertook interdiction missions during the month. Many of the bombers were now silver coloured, making a change from the drab camouflaged marking

previously carried. This was because the Americans were now on the offensive and felt less need for their aircraft to be camouflaged from the Luftwaffe. The Marauders moved to Normandy at the end of August and this brought an end to Hurn's wartime activity. Replacement gliders soon appeared at Tarrant Rushton as they would be needed for further wartime operations, such as the ill-fated Operation Market Garden Arnhem landings in September, and the Rhine Crossing in March 1945. The end of the war saw glider training continue until the summer of 1946 when the RAF moved out of the airfield.

Typhoon crews take a break. Due to the large number of fighters based at Hurn many of their crew had to live in tented accommodation. With the success of D-Day operations, the Typhoon squadrons left Hurn for bases in northern France.

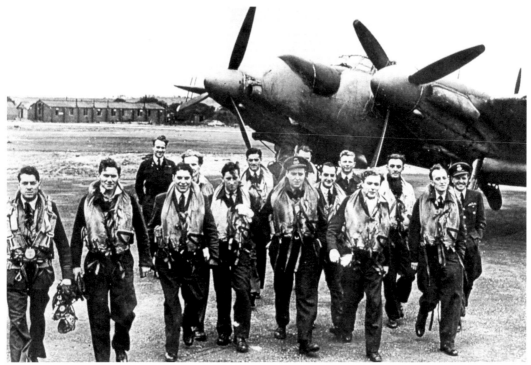

Mosquito night fighters were also based at Hurn over the D-Day period, tasked with keeping an eye on enemy shipping at night. This meant the airfield hosted around 150 fighters during June. Here the Mosquitoes crews seem in a happy mood.

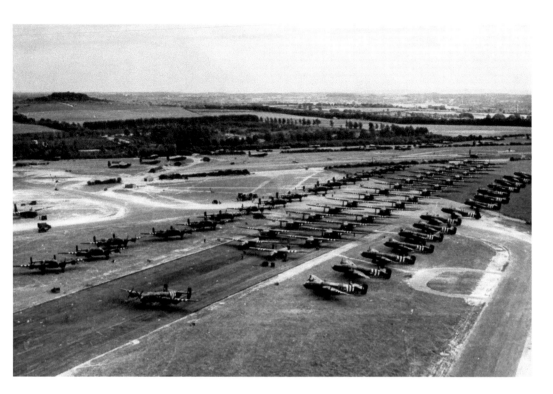

A well-known photo of Tarrant Rushton. Seen on the eve of D-Day are Hamilcar gliders, plus a couple of Horsas, waiting for their Halifax tugs. Note the black and white stripes applied to Allied aircraft to aid their identification in the heat of battle.

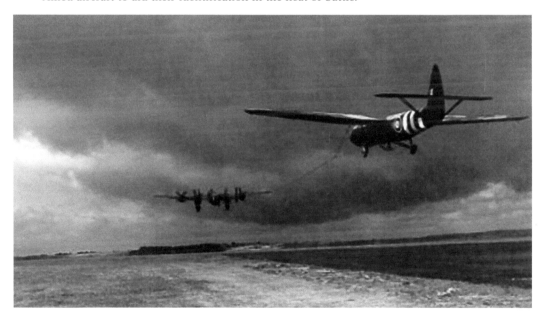

A Horsa assault glider departs Tarrant Rushton's runway under tow from its Halifax tug. The Horsa carried twenty-five fully equipped troops, while the larger Hamilcar was capable of transporting a small tank, among other equipment.

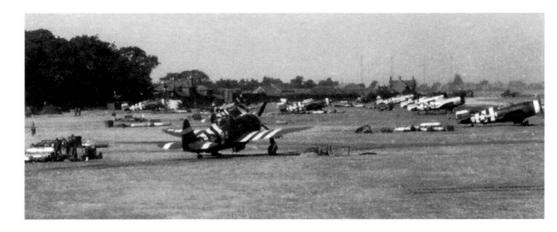

The Americans took over the airfield at Christchurch for D-Day operations. A Fighter Group of P-47 Thunderbolts arrived in March 1944, undertaking patrols over the D-Day period. As with the RAF Typhoons at Hurn, they soon moved to Normandy.

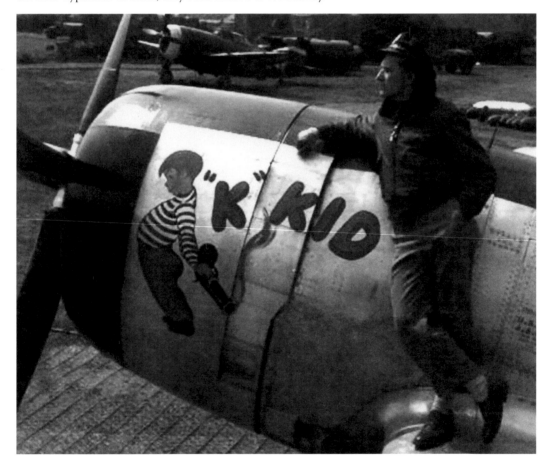

Unlike camouflaged RAF fighters of the time, the USAAF Thunderbolts were mainly silver coloured with decorative artwork added to their noses. Here one of the pilots poses with P-47 "K" Kid who appears to be a rather mischievous lad.

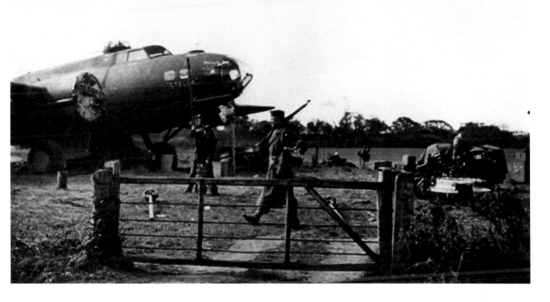

In April 1943 USAAF B-17 Flying Fortress *Stella* ran out of fuel over Dorset and made a successful landing in a field at Lytchett Minster, close to the Bakers Arms pub. Engineers arrived from its base in East Anglia to check for damage.

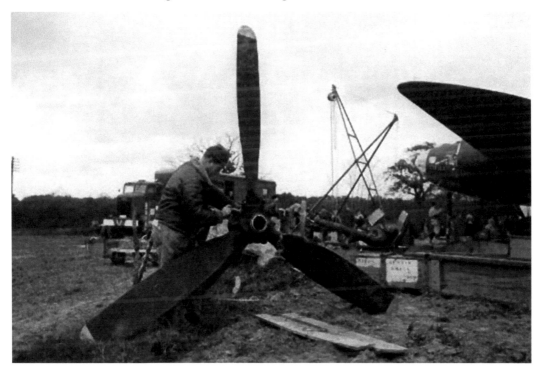

It was decided the undamaged Flying Fortress could be flown home. The engineers replaced its engines, flattened the field, removed the hedges and gave the all clear. The pilot easily lifted the bomber into the air and returned safely to base.

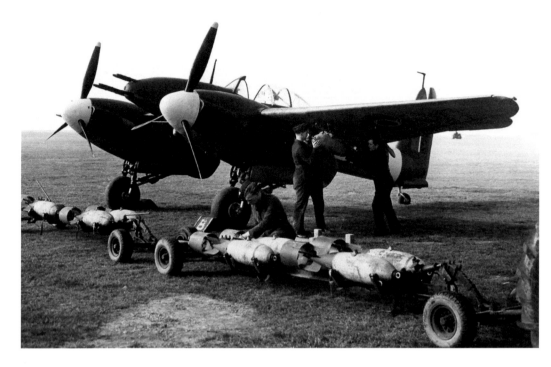

Warmwell continued to see a variety of RAF fighters, now carrying out operations over northern France. Whirlwind fighter-bombers arrived early in 1943 and, as can be seen, were equipped with underwing 250 lb bombs.

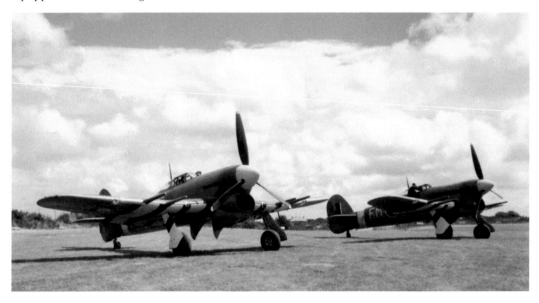

Typhoons were also used in the fighter-bomber role. Parked out on the grass are two aircraft of 257 Squadron which operated from Warmwell during 1943. The Typhoons left at the beginning of 1944 with the USAAF moving in for D-Day operations.

The Americans also arrived at Hurn for a few weeks after D-Day. Here crews of B-26 Marauder *Holy Moses* pose in full combat gear. The bombers undertook attacks over northern France to aid the Allies advance during July and August 1944.

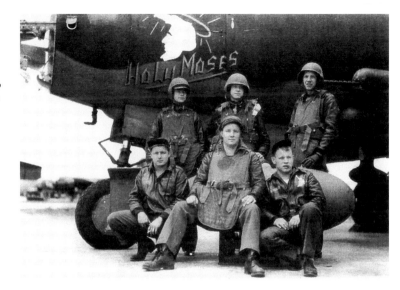

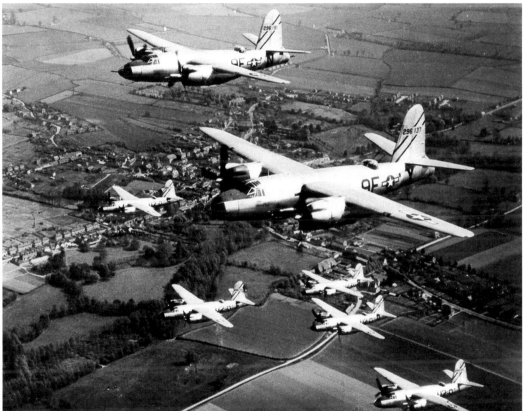

The majority of the USAAF Marauders were silver coloured, as seen in this formation. After only a few weeks of missions from Hurn the bombers were able to cross the English Channel to bases in northern France to continue their operations.

Here American airmen look out for returning crews from the watch tower. This was the original use of the control tower as it was used to watch aircraft movements. At that time control of aircraft was from a mobile van alongside the runway.

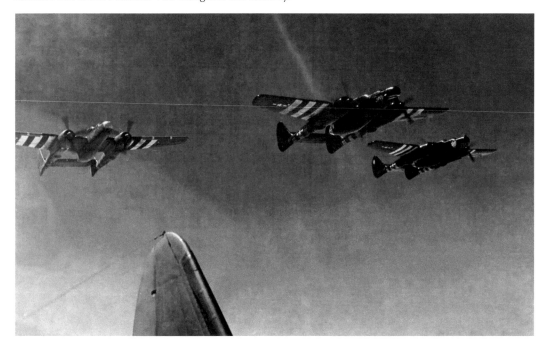

Hurn was also used by USAAF P-61 Black Widow night fighters for trials with RAF Mosquito night fighters. Their entry into American service was too late for D-Day but proved useful once they switched operations to the continent.

Return to Peace

With the majority of warplanes gone it was time to see silver coloured airliners take to the skies over Dorset. Consideration was given to reusing Christchurch for airline services, but it was decided that it was no longer suitable as an airport for the area. From 1 November 1944 Hurn/Bournemouth became a civilian airfield and a base for BOAC which operated limited services with Dakotas and Yorks to Iberia, North Africa and the Middle East. These services were not for the public but for Government Ministers and Military VIPs, the majority travelling down from London by Pullman train. With the end of the war in sight BOAC planned the resumption of its pre-war Empire Air Mail routes. First was to Sydney, flown by converted Avro Lancaster bombers known as Lancastrians. Initially carrying only nine passengers (plus mail), the service commenced on 31 May 1945 with the 12,000 miles journey taking sixty-three hours. The flights were operated in conjunction with Qantas, with crews changing en route at Karachi. Services to Johannesburg commenced in November with Avro Yorks which carried twelve passengers plus mail. September saw the opening of transatlantic services by American Airlines and Pan American World with Douglas DC-4s, which carried thirty-eight passengers. These were a great improvement over the airliners used by BOAC. The departures board at the airport was now able to show destinations such as New York, Chicago, Philadelphia and Washington. Passengers were sometimes rather bemused as the timetables showed their arrival point as London (Hurn). They did not realise how far the airport was from London and that their journey had to be completed by coach. Other major airlines soon appeared – Air India, KLM, Qantas, Sabena, South African Airways and Trans-Canada. It must be remembered that at the time there was no Heathrow Airport – it was still being built. So for a while Bournemouth was the country's major international airport. A one-off flight in May 1946 involved Halifax bomber *Waltzing Matilda*. Provided with rudimentary seating and crewed by Australian servicemen, it carried their families back to Sydney. Heathrow was officially opened on 31 May 1946. Despite only having very basic facilities, the airlines moved their services there so that passengers ended up much closer to the capital.

Across at BOAC's other local base, at Poole Harbour, services recommenced with Sunderlands flying to Lagos, Karachi and Calcutta. The Boeing 314s were switched from West Africa to serve Baltimore, the return to peace seeing four services a week. BOAC refurbished their austere Sunderlands, now fitted with luxury accommodation for thirty-five passengers. Services to Singapore commenced in January 1946, to Sydney in May, and to Hong Kong in August. The new transatlantic services by American Airlines and Pan American World into Bournemouth showed up the slow, if luxurious, service offered by BOAC. As a result, the Boeing 314s were withdrawn from the service in March 1946, the airline having to wait some months before it was able to introduce its own Constellation landplanes. The pre-war C-Class flying boats returned to Poole from South Africa from the autumn 1946, now worn out after wartime service. Of no further use, BOAC flew them to Hythe for scrapping. 31 March 1948 was the final day of BOAC flying boat services from Poole as the airline moved back to its pre-war base at Southampton. A non-BOAC flight saw Boeing 314

Bermuda Sky Queen depart for New York on 12 October 1946 carrying United Nations delegates. Due to strong winds and poor airmanship it was forced to alight mid-Atlantic almost out of fuel. It landed close to a US Coast Guard ship which, after a harrowing night, was able to rescue the passengers and crew. In the mid-1950s a number of BOACs old flying boats returned to the harbour, initially for storage, but eventually scrapping in 1957/58.

By the end of the war operations at Chickerell had greatly diminished, mainly being used by RN transports bringing VIPs to the nearby Portland Base. With the closure of Warmwell there were a few more visitors in connection with the nearby Chesil Beach and Lyme Bay Ranges, which remained in use during the 1940/50s. Flying returned to Portland in the summer of 1945 at a site adjacent to The Mere from where Sikorsky Hoverfly helicopters undertook development flying. They were a novelty for the Navy at the time, no-one quite knowing what they were most suitable for. Trials included radar calibration, gunnery spotting, deck landings and then air sea rescue, which proved the best initial use for the helicopters. The majority were fitted with floats for landing on the water and then getting pulled ashore on dollies. One made the headlines on 1 February 1947 when it landed on the deck of the battleship HMS *Vanguard* during a snowstorm. At the time the battleship was south of Portland carrying the Royal Family en route to South Africa. Two RAF Sunderlands were flying as their escort. The Hoverflies moved to Gosport in May 1947 where newer Dragonfly were about to be introduced into Naval service. Some were based at Portland in the spring of 1950 undertaking training of new pilots. The helicopters also made use of Chickerell, but flying activities ceased there by the summer of 1955 with the base officially closed in 1959. One road on the old airfield is Cobham Drive – a reminder of Sir Alan's pre-war visits.

The Portland site was redeveloped in the late 1950s when the Royal Navy decided that helicopters would be used in an anti-submarine role. HMS *Osprey* was officially opened on 24 April 1959. Initially Whirlwinds were operated in the training role but, unfortunately, they suffered from early problems which saw them frequently ditch in the seas around Portland. The early 1960s saw the arrival of the much-improved Wessex, plus the smaller Wasp that could operate from the decks of frigates. The base was greatly expanded in the early 1970s, with much additional land reclaimed from the sea. As well as many landing pads the base was provided with a short runway for use by heavily laden helicopters which needed rolling take-offs or landings. However, in March 1986 it was used by visiting Sea Harriers from Yeovilton. Sea Kings and Lynx arrived in the 1980s, with one Sea King squadron providing search and rescue cover over the local English Channel area from 1988. Defense cutbacks saw the base close on 31 March 1999. This was not before a final Open Day was held in October 1988, attended by Prince Andrew, with an extensive display of past naval helicopters.

It was not the end of the base as search and rescue operations were now carried out by Bristow Helicopters with Sikorsky S-61s, on behalf of HM Coastguards. This continued until June 2017 when the SAR operations were switched to Lee-on-Solent. The old base continued to see some use. Sea Kings training for German crews was undertaken between 2017 and 2020, and USAF CV-22 Ospreys appear at times. The Portland base hosted annual Navy Days that included displays by the resident helicopter squadrons. The Red Arrows would appear some years and 1987 saw a Widgeon flying boat. A surprise at the base in March 1998 was the arrival of a Heinkel He111 bomber. Carried underneath a large German CH-53 helicopter, it was en route from Seville to Duxford for preservation. There were often aviation contents at Bovingdon Tank Museum's display days. Both 1987 and 1989 saw demonstrations by a RAF Harrier.

50

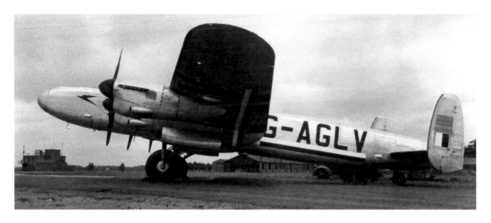

With the military gone Hurn became a civilian airport in November 1944; a few months before the end of war. From the spring of 1945 BOAC operated services to Sydney with Avro Lancastrians, which were converted Lancaster bombers.

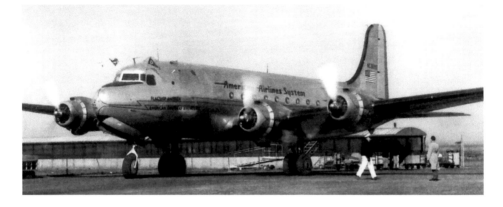

With the return to peace transatlantic services were operated by American Airlines and Pan American. Both airlines used Douglas DC-4s which were an advance over BOAC's aircraft. In due course Heathrow was opened and the airlines moved there.

Bournemouth Airport in the late 1940s. Wartime buildings now have a peaceful role with one in use as a terminal, although it looks more like a village cricket pavilion. The two aircraft parked on the grass belong to the BOAC Flying Club.

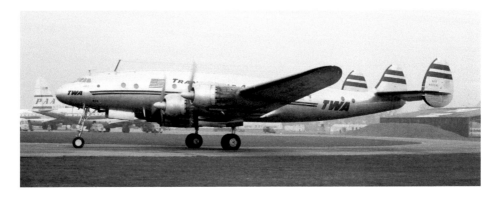

Due to smog around London, Bournemouth would burst into activity with diversions from Heathrow in the 1940s/50s. Many international airlines were seen, such as this TWA Constellation with Pan American Stratocruisers to its left.

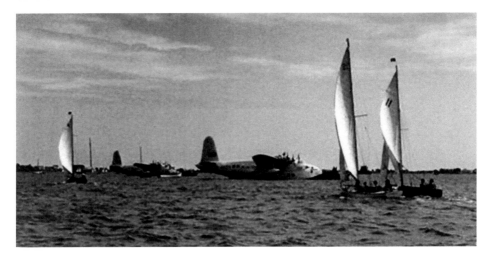

At Poole BOAC's flying boats were soon repainted silver and continued their services to the dwindling Empire. As can be seen, a major problem was the return of yachtsmen to the harbour who could cause inconvenience during take-offs and landings.

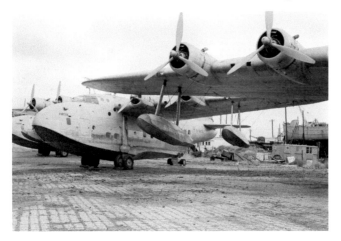

Flying boats had had their day with the return to peace and the introduction of more efficient landplanes. BOAC ceased flying boat operations in 1950 and later a number were stored at Hamworthy before being scrapped during 1957/58.

The Royal Navy commenced helicopter trials at Portland, in September 1945, using Sikorsky Hoverflies. At the time it was felt there was a great future for helicopters, but nobody knew quite what. Within a few years they became invaluable.

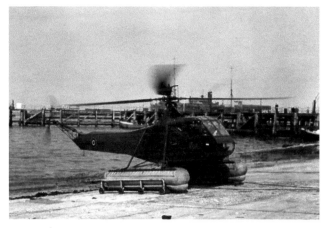

Chickerell airfield continued in limited use until the late 1950s, usually operating communication flights for VIPs visiting Portland. It was also used for helicopter trials, including that of the prototype Whirlwind in 1953, the type being ordered in large numbers for the Navy.

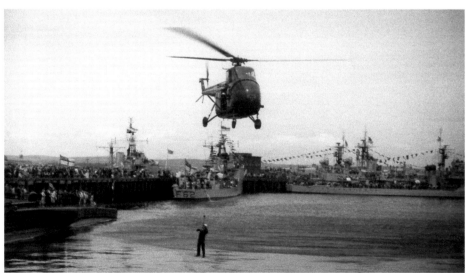

Regular Navy Days were held at Portland for many years, ending when the base closed in 1995. As well as being able to clamber over warships, the public were also treated to helicopter demonstrations. Here a Whirlwind 'rescues' a seaman in June 1960.

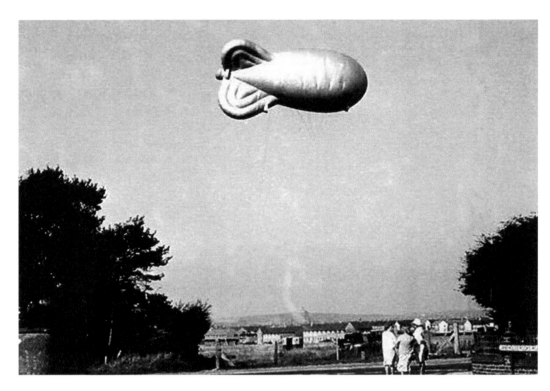

Although Chickerell airfield had closed, the site retained aerial activity during the 1960s. A Barrage Balloon is seen in use by the Army during a Territorial Army Summer Camp. In the background housing is slowly encroaching on the airfield site.

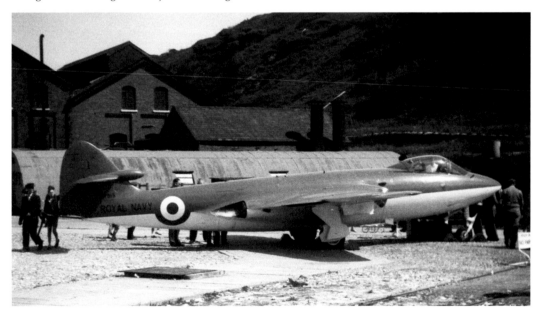

Seen at the 1960 Portland Navy Days is this Sea Hawk fighter. It is on display within the main Naval Base, not at the helicopter base, and had been brought in by road especially for the event. The Navy had a number of such travelling exhibits.

The helicopter base at Portland was greatly expanded in the early 1970s, at which time Sea King, Wasp and Wessex helicopters were in use. HMS Osprey was the Navy's main anti-submarine training base. A visiting Sea King from Culdrose prepares to depart.

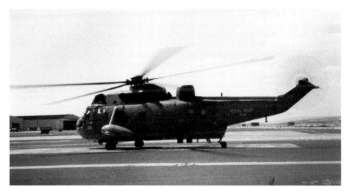

Sea Harrier FRS1s of 800 Squadron made use of Portland's short runway in March 1986, while on detachment from Yeovilton. Something not expected at what the locals regarded as a heliport. It was used in the late 2010s by USAF CV-22 Ospreys.

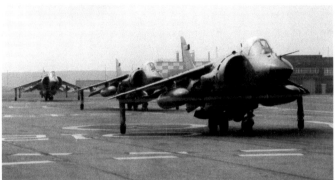

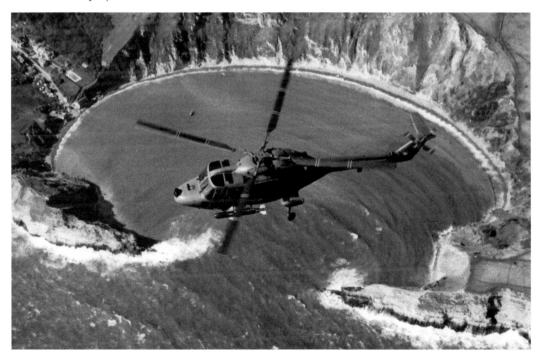

A Westland Lynx accurately positions itself over Lulworth Cove during a photo shoot. Lynx were the final helicopters in naval service at Portland, transferring the short distance to Yeovilton early in 1999 prior to HMS *Osprey*'s closure in March.

Industry

Having been abandoned at the end of the war, Tarrant Rushton was used for training by troops from nearby Blandford Camp. However, it was to return to aviation and reintroduced Sir Alan Cobham to Dorset. His company, Flight Refuelling, had continued its development of in-flight refuelling but sought a new home. So, in 1947 the Air Ministry allocated the airfield to the firm, their first Lancasters arriving in September. Two were in use as tankers and two as receivers. The following July the Lancasters were pressed into service for the Berlin Air Lift to deliver fuel to the beleaguered city. Other Lancasters were soon added to the fleet for the period of the air lift. Perfection of the firm's probe and drogue method of refuelling continued, with the USAF showing greater interest than the RAF – the naturally perceived customer. A Meteor took off from Tarrant Rushton early on 7 August 1949 and, during the course of the day, was refuelled ten times from a Lancaster tanker before landing having been airborne for twelve hours. This seemed to impress the Americans more than the RAF as they sent three KB-29 tankers and two F-84 fighters to Tarrant Rushton in 1949 for further trials. The RAF finally showed interest and had a squadron of Meteors converted by 1951 to receive fuel from a Lancaster or Lincoln tanker. A Canberra bomber was converted as a faster tanker in May 1953 and the aircraft remained with Flight Refuelling as a trials aircraft for the next forty-five years.

In the early 1950s Flight Refuelling also operated a flying school on behalf of the RAF. This was at the time of the Korean War crises and the school provided former pilots with a refresher course. Flying was undertaken with a fleet of Meteors and Vampires, the school disbanding in June 1954 following a truce in the Korean War. Due to its experience with Meteors, Flight Refuelling was selected by Gloster Aircraft to overhaul a number of Meteors for foreign air forces. These included Egypt, Israel and Syria, with care having to be taken to ensure none of the pilots from these non-friendly countries met. Work on Meteor overhauls continued until the spring of 1957. Flight Refuelling was also involved in the development of an unmanned target version of the Meteor. Over 200 Meteors were eventually converted as target drones for the RAF and the Australians. A range of towed targets was also developed by the company leading to the widely used Rushton target. The RAF selected Tarrant Rushton as an emergency dispersal airfield for use by its V-Bombers from the late 1950s. This would be for when a Russian attack was imminent, and the bombers would be moved away from their home bases. It was also reported that Bournemouth would be used in such circumstances. In the event it was only Tarrant Rushton that saw occasional visits of Valiants or Victors on exercises which continued until the late 1960s. Much of Flight Refuelling's non-flying work moved to its large new factory in Wimborne in 1963. Tarrant Rushton closed in the summer of 1980 and Flight Refuelling transferred their flying activities to Bournemouth. The land reverted to agricultural use with two of the wartime hangars being used by local farmers for storage. Close to the former main gate a memorial was erected in 1982 to honour all those who had flown from the airfield.

The Airspeed factory at Christchurch was producing Mosquitoes at the end of the war and the bomber continued in production until 1948. By then Airspeed was involved in the development of the elegant Ambassador airliner, with the prototype flying in July 1947. Much test flying was undertaken, during which there were a number of incidents,

mainly when the airliner's undercarriage collapsed. The problems were eventually overcome, and the airliner entered service. From July 1951 Airspeed were merged into the de Havilland Aircraft Company, whose titles now appeared on the front of the factory. Twenty Ambassadors were built for BEA, but de Havilland decided they would not spend money on further aircraft. Instead they went ahead with the production of jet fighters which were much in demand by the RAF in the early 1950s. The prototype Vampire Trainer flew in November 1950 and was ordered in large numbers by the RAF, Royal Navy and many overseas air forces. Production continued until March 1955, by which time Venom and Sea Venom fighters were appearing. The Christchurch factory was responsible for the development of the Sea Vixen fighter for the Royal Navy. Developed from the DH110 of the early 1950s the prototype Sea Vixen flew from Christchurch on 20 June 1955. Due to its size test flying of the fighter took place from nearby Bournemouth – the runway at Christchurch being considered too short. De Havilland became part of the Hawker Siddeley Group and in July 1962 the factory closed as part of the rationalisation of the British aircraft industry. For a number of years, a Sea Vixen was displayed on a plinth in front of the former factory.

When BOAC moved its maintenance section from Bournemouth to Heathrow in 1950, they left behind a number of empty hangars. These were taken over by Vickers-Armstrongs in 1951 as a temporary flight test base for prototypes of its Valiant V-bomber and Viscount airliner. During a flight on 12 January 1952 the prototype Valiant suffered an uncontrollable fire in its engine area and tried to make it back to Bournemouth. While descending it flew over the town with the flames clearly visible to the onlookers below. The severity of the fire increased, so the pilot ordered the crew to bail out with the bomber crashing at nearby Bransgore. Unfortunately, the co-pilot was killed when he hit the tail plane on ejecting. The smoke could be seen from the control tower at Bournemouth, where the duty crew were surprised to receive a phone call from the pilot to say he was safe. His parachute had brought him down close to a phone box and he requested help for the rest of the crew. Later in 1952 flight testing moved to Wisley, nearer Vickers main airfield at Weybridge. Vickers decided to remain at Bournemouth as they needed extra production space for Varsity trainers being built for the RAF at Weybridge. Vickers had orders for large numbers of Valiants and Viscounts and these were to be produced at Weybridge. Additional orders resulted in the Viscount also being built at Bournemouth, following the Varsity down the production line from the end of 1953. The turbo-prop Viscount went on to be a successful airliner with worldwide sales, with two thirds of the 438 built produced at Bournemouth. Vickers-Armstrongs became part of the British Aircraft Corporation on 1 July 1960 and, after the final few Viscounts had been built, the factory was taken up with development of the BAC One-Eleven 'Bus stop jet'. The prototype flew on 20 August 1963 and the airliner entered service in April 1965. Like the Viscount, it was sold worldwide, with many introducing passengers to Inclusive Tour holiday flights. Production continued until the early 1980s but, with no further work in hand, BAC closed the factory in June 1984. Since then their former hangars have continued to see aviation-related activities.

When Flight Refuelling moved their flying activities to Bournemouth in 1980 it was anticipated that it would be only for a short time, but this was to change following the Falklands War of 1982. The British forces realised they needed to be more prepared for enemy attacks. FR Aviation was established in 1985 to provide a fleet of Falcon 20s for electronic warfare and threat simulation training work in conjunction with the RAF and RN. The Falcons would operate as targets for RAF fighters and RN gunners – all electronically. During the 1990s the well-known Thursday War was established with the Navy off Portland, moving to the Plymouth area when the base closed. The fleet would be

'attacked' by the Falcons acting as the enemy, the naval gunners trying to shoot them down electronically. The Falcons continue to be a major user of Bournemouth Airport and will be for a few more years yet. FR Aviation was also involved in the conversion of RAF VC10s transports into tankers during the 1990s. This was to be followed by the major rebuild of the RAFs fleet of Nimrods into MRA4's on behalf of British Aerospace. Problems with the design – nothing to do with FR Aviation – saw the work cancelled. In 1994 FR Aviation became part of the new Cobham plc group.

Tarrant Rushton airfield received a new lease of life in 1948 when Flight Refuelling moved in. Although still perfecting a system of in-flight refuelling, most of its Lancastrians were soon pressed into service to carry fuel during the Berlin Air Lift.

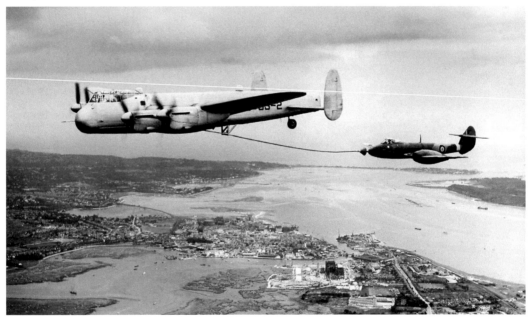

Demonstrating that in-flight refuelling was finally practical, a Lancaster tanker refuels a Meteor fighter during a twelve-hour flight on 7 August 1949. There were a series of photos of the event, this one showing the pair overflying Poole Harbour.

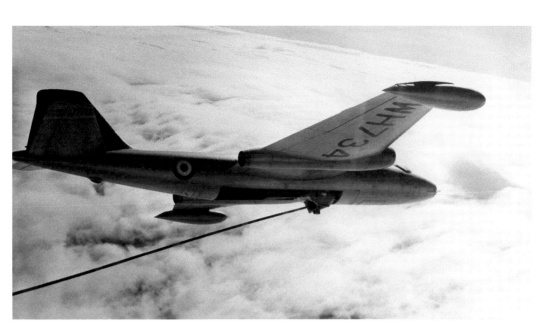

To replace the Lancaster, this Canberra bomber was converted as a tanker in 1953. Flown by Flight Refuelling on a number of trials, which later included testing various towed targets, it remained a trials aircraft for over forty years.

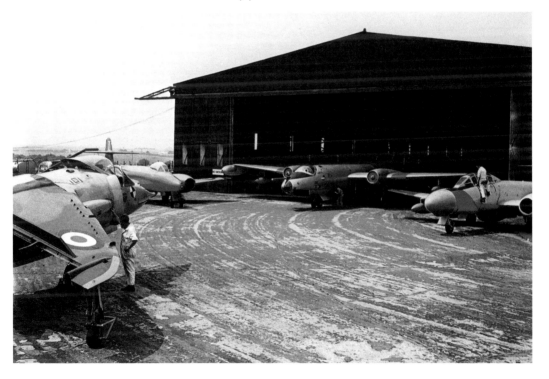

Seen outside Tarrant Rushton's flight test hangar are some of the trials aircraft in use during the 1970s. Left to right are a Harrier (non-flying), Meteor drone and Canberra and Meteor target tugs. When the airfield closed some moved to Bournemouth.

The Airspeed factory which was built at Christchurch airfield in 1939/40. Initially used to build Oxford trainers, later wartime production included Horsa assault gliders and Mosquito bombers. The Isle of Wight is on the horizon.

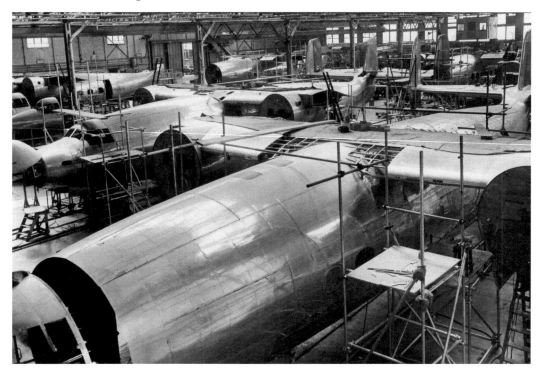

Production under way on Ambassador airliners for BEA in the early 1950s. The factory was taken over by de Havilland in July 1951 and shortly after they cancelled any further Ambassadors. They felt there were insufficient development prospects.

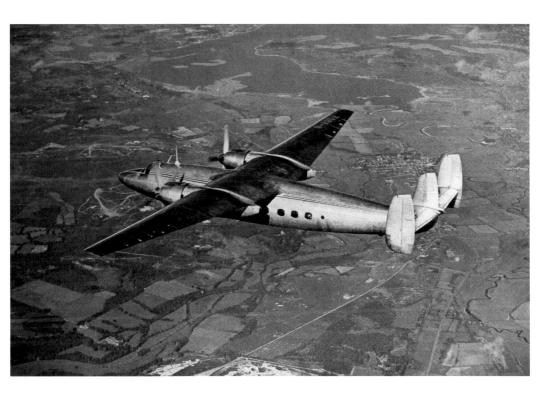

Prototype of the elegant Ambassador on test over Dorset during 1948. Poole Harbour can be seen at the top and Wareham above the aircraft's tail. The airliner entered service in 1952 with BEA – the only airline to order the Ambassador.

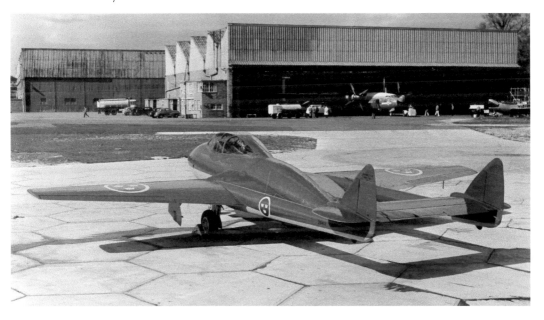

De Havilland made use of their Christchurch factory for production of the Vampire Trainer. First flown in November 1950, many were ordered by the RAF and Royal Navy as well as foreign air forces. This one is destined for the Swedish Air Force.

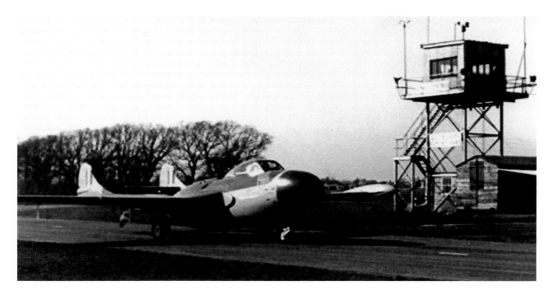

From 1952 Venom fighters joined Vampires on the Christchurch production line. Again, large numbers were ordered for the RAF and Royal Navy, with many for the Australian Navy. One of the Venoms passes the airfields rather basic control tower.

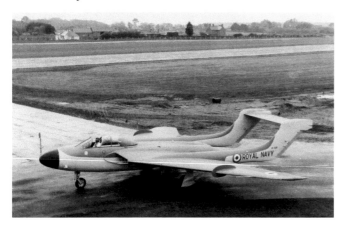

Christchurch was tasked with developing the DH110 fighter into the Sea Vixen for the Royal Navy. Seen around the time of its first flight in June 1955 is the prototype Sea Vixen, with the airfields newly completed hard runway in the background.

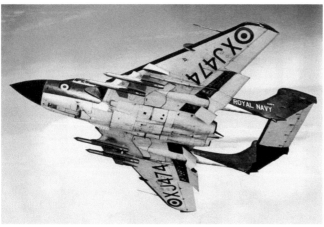

The first production Sea Vixen flew from Christchurch in March 1957 and was the first naval fighter not to be fitted with guns. Instead it was fitted with four Firestreak missiles for its role as an all-weather naval fighter.

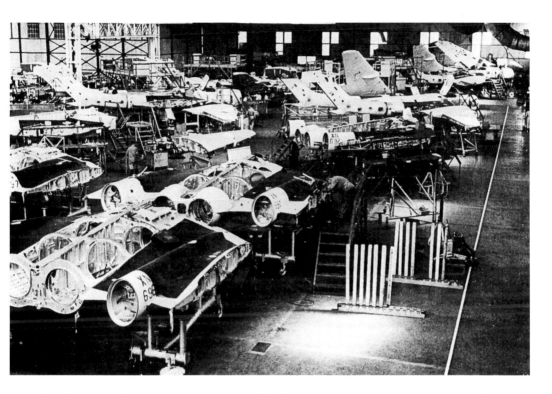

Sea Vixens on the assembly line late in 1961. Production for the Navy continued until August 1962 when the factory was closed by de Havilland and Sea Vixen work switched to its Chester factory. Christchurch airfield lingered on until 1969.

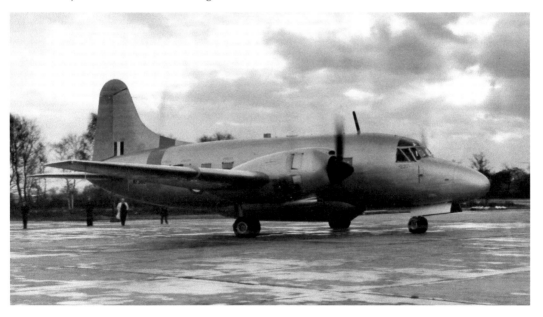

At Bournemouth Vickers-Armstrongs took over most of the former BOAC hangars in 1951. These were converted for the production of Varsity trainers for the RAF, one of which undertakes engine runs before its first flight.

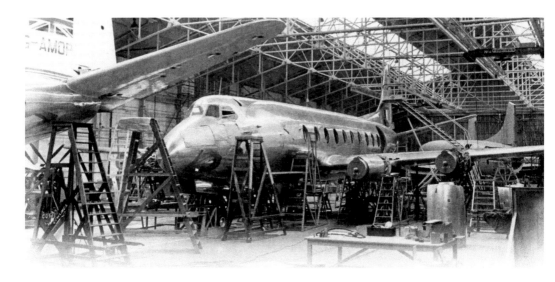

With a full order book for its Viscount airliner, Vickers-Armstrongs decided to build these at Bournemouth as well as at Weybridge. This autumn 1953 view shows work under way on an Aer Lingus aircraft with the final RAF Varsity in the background.

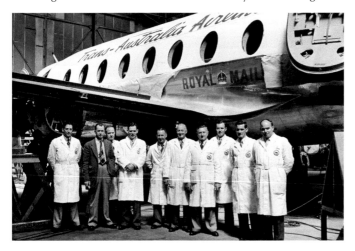

Crews from Trans-Australia Airlines pose in front of their first Viscount in June 1954. By this time Vickers-Armstrongs had expanded the length of the former BOAC hangers to cope with further Viscount orders from North America.

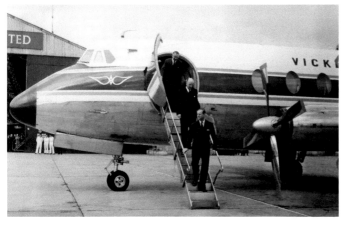

Always having an interest in aviation, the Duke of Edinburgh visited the Viscount production line at Bournemouth in April 1958. Following him down the steps is Sir George Edwards – the Managing Director of Vickers-Armstrongs.

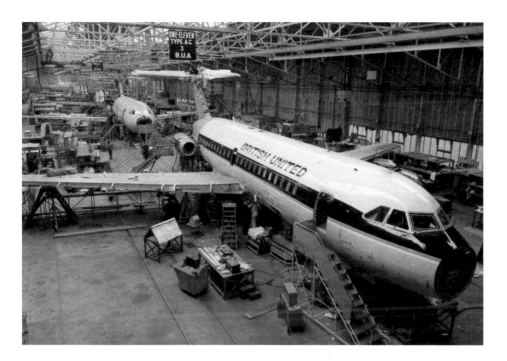

The Bournemouth factory became part of the British Aircraft Corporation in 1960, from when it undertook design and production of the BAC One-Eleven airliner. This 1964 view shows early production aircraft for British United Airways.

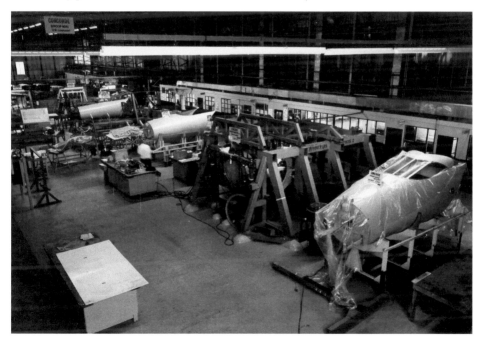

The BAC factory was also involved in other aviation work. During 1973/74 this included Concorde noses which were then delivered to the production line at Filton. With a lack of further One-Eleven orders the factory closed in 1984.

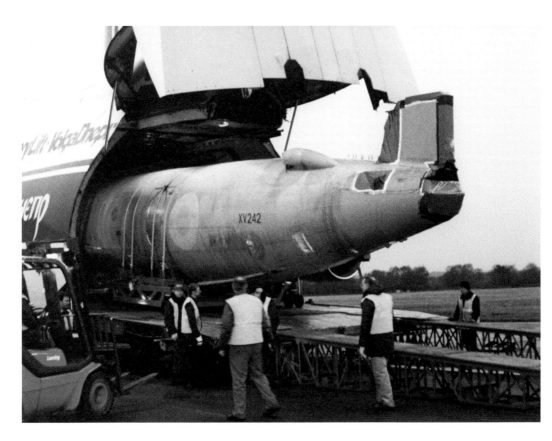

When Flight Refuelling moved to Bournemouth Airport, they undertook various RAF contracts. One was to be the major rebuilding of existing Nimrod patrol aircraft, with fuselages arriving inside Antonov An-124 freighters.

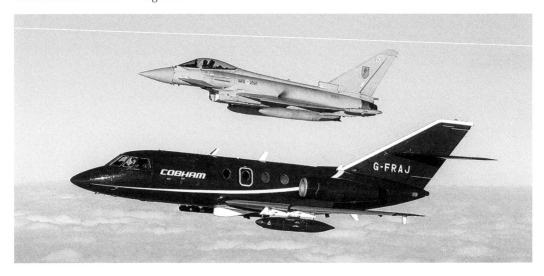

The new name of Cobham is seen on the side of their fleet of Falcon 20s currently used for threat simulation training with the RAF and Royal Navy. In use since 1985, this one is operating in conjunction with a RAF Typhoon FGR4 of 6 Squadron.

Civilian Flying

Civilian flying returned to Christchurch in the summer of 1948, although hopes to resurrect the Bournemouth Flying Club failed. Instead 1950 saw the formation of the Christchurch Aero Club which operated a fleet of Austers and Tiger Moths. The airfield was also home to a RAF Gliding School which taught basic gliding skills to local ATC cadets. Their gliders would frequently be seen soaring over the beach at nearby Mudeford. Flying continued until the early 1960s when it was announced that, following the departure of de Havilland, the airfield would close. The Gliding School moved to Old Sarum in July 1963 and the Aero Club ceased flying in the summer of 1964. The airfield still continued to see occasional visitors until it finally closed in the summer of 1969. Memories of old times can be found in road names – de Havilland Way, The Runway and Comet Close (among others) – on the site.

There were few based light aircraft at Bournemouth in the 1950s due to the proximity of the more suitable Christchurch. This was to change when it closed and private pilots had to seek a new home. September 1961 saw the Bournemouth Flying Club re-established at Bournemouth with an Auster and a Dragon Rapide. Its initial clubhouse was a wooden building left over from the war, close to the terminal. In the summer of 1973, it moved to more substantial premises on the northern side of the airport. Bournemouth continues to be used by other flying schools from around the country for training experience, also being a stopping off point for pilots clearing customs.

The pre-war Dorset Gliding Club was reformed in 1960 and operated from Gallows Hill, close to Bovington Army Camp. Air tows were provided by Tiger Moths, one of which crashed in October 1963 with a second crash landing only a couple of months later. Early in 1965 the club moved to Compton Abbas which initially provided better facilities. They did not stay very long before moving to Tarrant Rushton, where they remained until 1979. The closure of the airfield forced the club to move once more, this time to Old Sarum. Again, an uncertain future saw the club move yet again in October 1992, this time to their present home at Eyres Field – the site being named after one of the club's founders. Air tows are provided to enable the glider pilots to reach the thermals provided by the nearby Purbeck Hills. They then spend their time soaring over the Dorset countryside before returning to base.

A new airfield location was Compton Abbas, south of Shaftesbury. This grass airfield opened in the summer of 1962 and initially was home to the Shaftesbury Flying Club. This was replaced by the Dorset Flying Club in 1967 operating the usual Austers and Tiger Moths of the era. Over the years activities and facilities have expanded; the location and views within the Dorset countryside being excellent. By the 1990s the airfield and training were operated by Abbas Air. They organise frequent fly-ins and sunny weekends will see the arrival of many aircraft enabling their pilots to make use of the restaurant. At times there are visits to the airfield by military helicopters from Middle Wallop or Yeovilton, their pilots dropping in for a cup of tea. The summer of 2014 even saw the arrival of a small executive jet. The 2020s sees flights offered in vintage Tiger Moths, Chipmunks, Stearmen and Harvards.

Dorset has always seen plenty of helicopter activity. Modern times has seen the Dorset & Somerset Air Ambulance based from March 2000 at Henstridge Airfield.

Situated on the Dorset/Somerset border, the hangar is in Somerset, but the southern boundary is Dorset. The Dorset Police helicopter was originally based at Winfrith Police HQ, but now flies from Bournemouth Airport. It no longer just serves Dorset, but anywhere that it may be needed in the south. Although the Coast Guard helicopter is currently based at Lee-on-Solent it can swiftly reach the Dorset coast, where frequent exercises are also undertaken. Military helicopters are frequent visitors to the Royal Marines base at Hamworthy with the 2020s seeing Chinooks, Wildcats and CV-22 Ospreys. There was a rather dramatic arrival on 15 July 2002 when a Coast Guard Sikorsky S-61 suffered an engine fire while flying over the harbour. It made a hasty landing at the base with the crew running for their lives as the helicopter burst into flames and burnt out.

During the 1980s Bournemouth Airport hosted well-attended air shows. There was excitement at the August 1984 show when an RAF Phantom gave an unplanned live election seat demonstration during a take-off emergency. The pilot shouted 'eject' which the navigator did. But the pilot regained some control and made a successful take-off from the grass! The Red Arrows would appear at Dorset's coastal towns during each summer, usually as part of their Carnival or Regatta weeks. This ensured that crowds flocked to Lyme Regis, Weymouth, Swanage and Bournemouth whenever they appeared. Later the display at Bournemouth was held separately from the Carnival event. Run by the Bournemouth Red Arrows Association the events saw large amounts raised for charity over the years. From 2008 the displays were combined with the newly established Bournemouth Air Festival which is one of the South Coast's major attractions. Tragically, after their 2011 display, the Hawk of Jon Egging crashed on its way back to the airport and his death is marked by a memorial on the town's East Cliff. Also raising funds for local charities is the Dorset Plane Pull held at Bournemouth Airport each summer. Here competing teams see which one can pull a 35,000 kg Boeing 737 over 50 metres in the shortest time.

Over the years airline services at Bournemouth Airport have slowly increased. The 1960s/70s saw services to other parts of Britain, the Channel Islands and northern Europe. Among the more memorable were the cross-channel car ferry services operated by Silver City. Your car would be driven up a ramp into the aircraft, you would then sit in the passenger cabin while being flown to the Channel Islands or Cherbourg. There were few sea ferries crossing the English Channel in those days. By the 1980s/90s the airport was seeing more holiday flights to destinations around the Mediterranean. The well-known name of the time was Palmair which operated its services with a fleet of just one aircraft. Each flight would be seen off by the company's director, Peter Bath, often escorting the passengers to their seats. It was also Peter who helped organise the visit of Concorde to open the airport's extended runway on 21 April 1996. This enabled Boeing 747 Jumbo Jets to visit the airport at times; notable were two used by an Arab Sultan as his VIP transports. The 1990s also saw the arrival of the low-cost carriers offering European destinations at cheaper prices. However, as their business expanded the carriers switched to the more profitable Mediterranean holiday destinations, which remains Bournemouth's main business at the beginning of the 2020s with a new terminal brought into use in 2010. With capacity restrictions at London's airports it is anticipated that holiday flights will have to relocate elsewhere. Bournemouth's present owner – Regional & City Airports – look forward to these future benefits.

It was the early 1950s before Bournemouth saw a resumption of air services. Parked in front of the Passenger Lounge is a Jersey Airlines Dragon Rapide, which operated services from the Channel Islands and then northwards to Manchester.

With increased business Jersey Airlines replaced their Dragon Rapides with de Havilland Herons in the mid-1950s. They definitely had a more modern look for carrying passengers to their summer holidays in the Channel Islands.

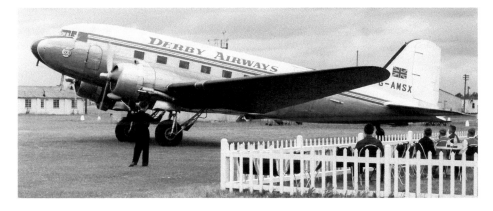

Many airlines called at Bournemouth in the 1950s/60s to clear customs before heading off across the English Channel. Derby Airways was one of them, with a Dakota seen preparing to depart. Note the closeness of the public viewing area.

Passengers waiting inside Bournemouth's terminal in the early 1960s – it was a converted Second World War building. The main difference from today is the attire of the travellers, they would look most out of place on a present day Tui or Ryanair flight.

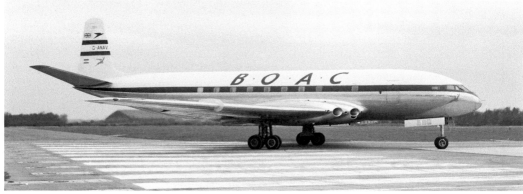

BOAC still made use of Bournemouth for crew training. De Havilland Comet 1s were seen during 1953/54 and were most impressive when you parked your car at the end of the runway as they landed almost on top of you.

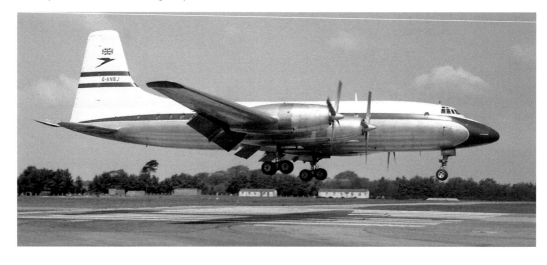

Bristol Britannias also made use of Bournemouth in the late 1950s, with two based at the airport for training. The advent of jet airliners meant that Bournemouth was no longer suitable for training as the runway was not considered long enough.

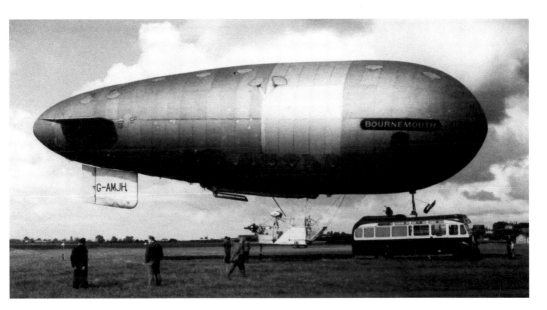

Above: The airship *Bournemouth* was intended to be a publicity machine for the town. It suffered many problems during testing at Cardington during 1951/52, its fate being sealed due to stability problems and lack of finance.

Right: This was the control gondola carried underneath *Bournemouth*. It was constructed at the airport before being taken to Cardington. There was a very basic cabin for three crew with its pusher propeller very close to their accommodation.

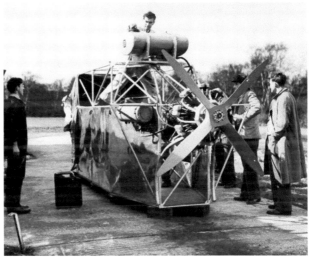

A charter flight to Switzerland by a BEA Viking organised by local firm Bath Travel in the early 1950s. A very young Peter Bath stands on the right-hand side of the passengers where, again, their travelling attire is definitely of its time.

71

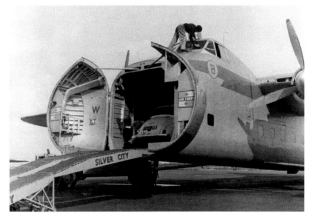

Bournemouth was used by Silver City in the late 1950s/early 1960s for its car ferry operations to the Channel Islands and Northern France. At the time it was the easiest way of getting your car abroad – there were no roll-on/roll-off ship ferries.

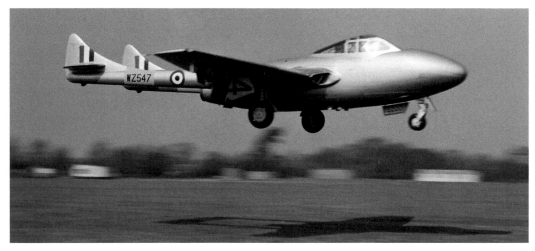

Bournemouth continued to see a variety of military aircraft. Here is a Christchurch-built de Havilland Vampire Trainer on a test flight during 1954. Venom and Sea Vixen fighters built at Christchurch were all test flown at Bournemouth.

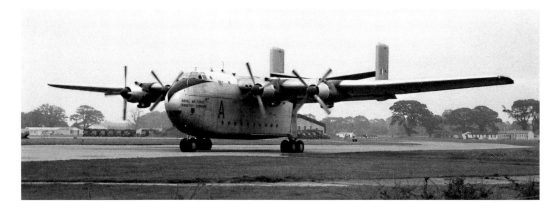

RAF aircraft also appeared in service. In 1956 this Beverley transport has just collected a load of parachutists; you can see their lorries in the background. This was in connection with a military exercise taking place on Salisbury Plain.

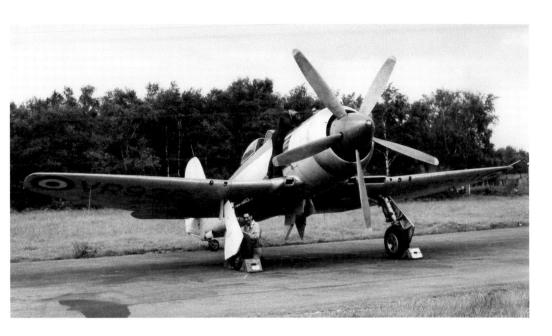

Airwork Services had a base at Bournemouth, including its Fleet Requirement Unit, which operated surplus military fighters to act as radar targets for naval warships and fighters. This is a Sea Fury; the navy's final propeller fighter.

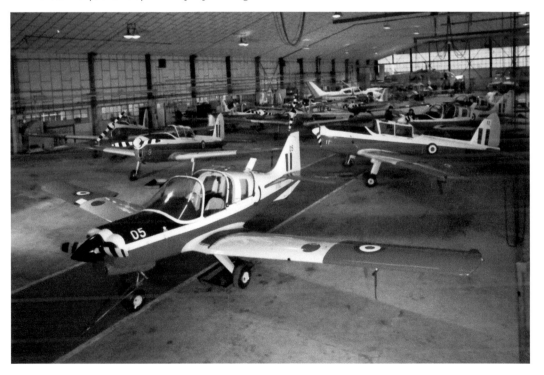

Airwork Services also undertook aircraft maintenance at Bournemouth. In the 1980s their hangar contains RAF Bulldogs of Southampton University Air Squadron and Chipmunks of Air Experience Flight which introduced Air Cadets to flying.

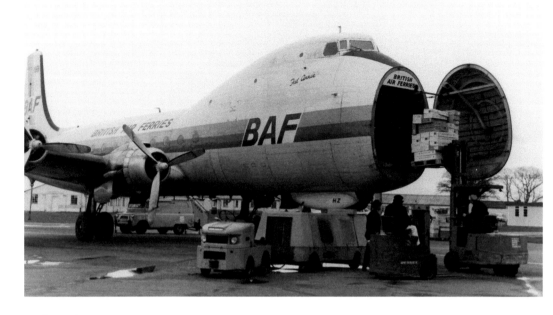

In the mid-1960s British Air Ferries Carvairs replaced the Silver City aircraft. As well as the car ferry service, the aircraft carried goods and produce to and from the Channel Islands. This was important business for Bournemouth.

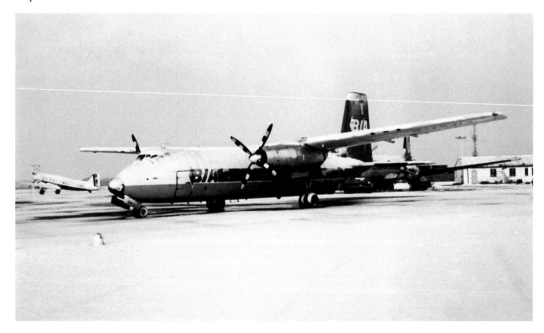

A wintery morning scene on Bournemouth's apron. Covered in snow are a BIA Herald and a Dan-Air HS748, while in the background is a Dakota freighter. All three were regular airliner types seen in service at Bournemouth.

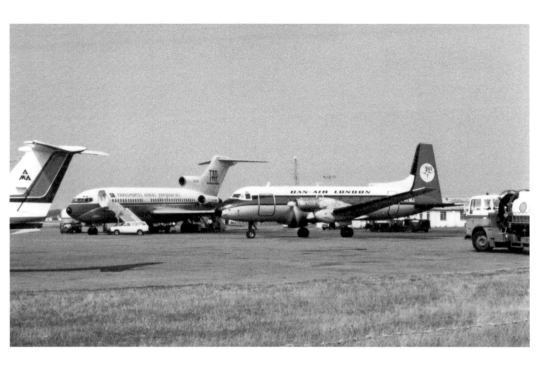

A busy time at Bournemouth. A Dan-Air HS748 departs on another flight to Jersey, while in the background is a TAP Boeing 727 awaiting passengers for their holiday flight to the Algarve. Mediterranean resorts have always been popular destinations.

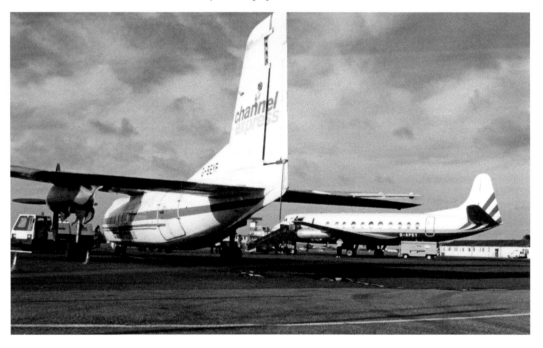

The Herald and Viscount were two airliners frequently operating services at Bournemouth. The Channel Express Herald is in use as a freighter on Channel Island routes while the Viscount is visiting on an enthusiasts' charter.

Inside the Christchurch Aero Club clubhouse in the mid-1950s with a number of former RAF fliers. Behind the bar is Tommy Marshall, who ran the club until it closed in 1964. Training was carried out on Austers and Tiger Moths.

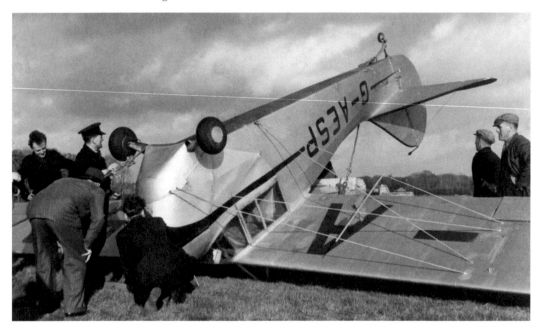

Post-war flying activities at Christchurch did not always go according to plan. Here members of the Aero Club offer their advice on what to do with this BOAC Flying Club Aeronca 100 which has come to grief on landing.

Refuelling a Club's Tiger Moth – a scene at many an airfield in the 1950s/60s. Many of the club's fleet were surplus RAF aircraft which were rebuilt by their engineers. Training flights were often undertaken over Christchurch Bay and the Solent.

Dragon Rapides appeared in the late 1950s to undertake charter operations, as well as pleasure flights, over the local coast. The author had his first flight in this aircraft in 1959 – a present for having completed his GCEs.

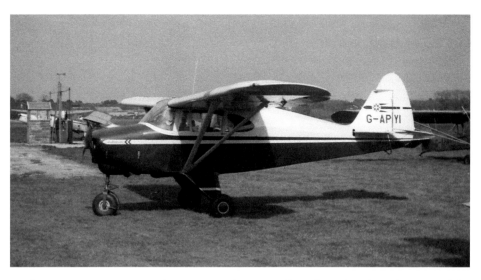

Modern American Cessna and Piper aircraft appeared at Christchurch at the start of the 1960s. Like this Piper Tri-Pacer they were fitted with a nose-wheel undercarriage, whereas British aircraft of the time still had outdated tailwheels.

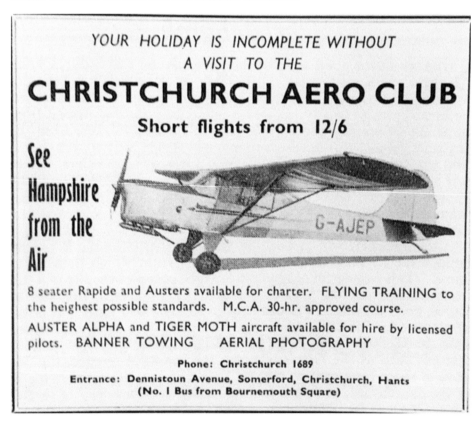
A flight for 12/6 (67½p) in an advert for the Aero Club which was originally situated in Hampshire until its 'move' to Dorset. During summer months the club's business was boosted by being situated in a popular holiday area.

Christchurch was also home to a RAF Gliding School where basic flying instruction was given to local Air Cadets. Pre-flight instruction is being given to a pilot in a Slingsby Cadet, one of a number of types operated by the School.

Instructor and pupil ready to depart in another Cadet. The glider was towed into the air by a rope attached to a winch, usually only undertaking a short flight over the local area. It was unusual for any great height to be reached by the glider.

Gliding continues over Dorset with the gliders of the Dorset Gliding Club based at Eyres Field, near Bovington. This Schleicher ASK-13 is one of a number awaiting its next flight. Note the Flying Control van in the background.

The Gliding Club makes great use of air tows with a variety of tugs operated over the years taking gliders to thermals generated by the Purbeck Hills. Seen in front of their clubhouse this Piper Super Cub was in use in 2019.

There are a number of small airstrips situated around the county. This is Newton Peverell which is located close to Sturminster Marshall and houses a number of light aircraft and microlights, including this homebuilt Denny Kitfox.

A deceptive appearance – it is not an accident! This Colomban Cri-Cri homebuilt spent a number of years in the 2010s up a tree as an attraction on the A35 to the east of Dorchester. It now resides in the Bournemouth Aviation Museum.

In the late 1970s the remains of this Sopwith Pup were found in a barn 'somewhere in Dorset' and was later sold at auction for £20. Its restoration has been a slow process – this is the fuselage in 2017. However, one day it should fly again.

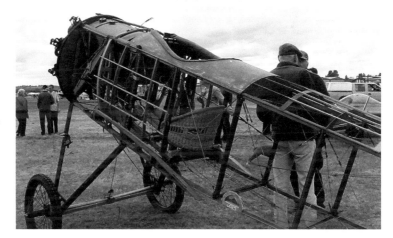

The Sir Alan Cobham Lecture Theatre at Bournemouth University, named to honour the pioneer who later lived in the town. The university's library is named after his son – Sir Michael Cobham – who succeeded his father in the family business.

Compton Abbas opened in the spring of 1962. Situated on the hilltops to the south of Shaftesbury the airfield has grown in popularity over the years. This Dragon Rapide was in use during 1965 by the local parachuting club.

A view at Compton Abbas on a rather damp British summers day in August 1966 sees a visiting Druine Turbi. In the background are an Auster and Tiger Moth – typical of flying club aircraft of the time – plus the airfield's initial hangar.

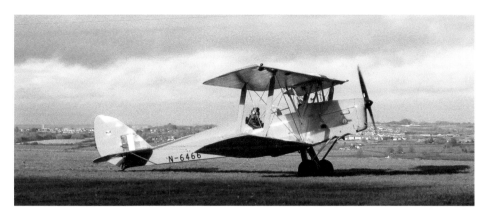

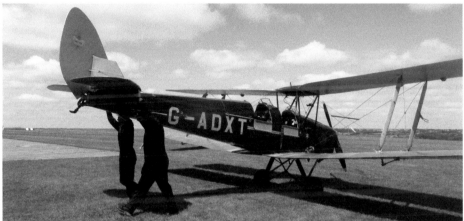

A visit to Compton Abbas at the present time will see a wide variety of historic aircraft. A Tiger Moth taxies out on a sunny day – Shaftesbury is in the background. Ground handling of a Tiger Moth is simple – sometimes only one person is needed. An American pre-war classic is this Stinson Reliant 'executive aircraft' of 1942 vintage.

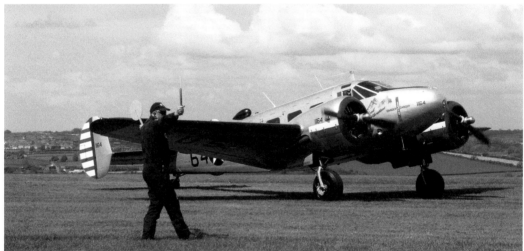

This North American Texan/Harvard proved a popular draw for pleasure flights in the late 2010s. A marshaller guides in a visiting Beech 18 at one of the many fly-ins held at the airfield. Another view of the airfield during one of its fly-ins – aircraft parking stretches into the distance with public viewing to the right.

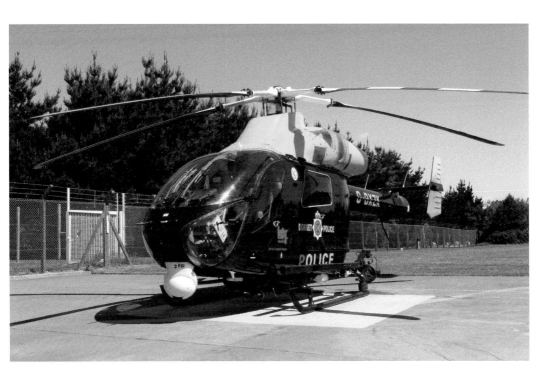

Dorset has always seen helicopter activity, with emergency services making increasing use of them. Dorset Police originally based this MD902 Explorer at their Winfrith HQ. Now based at Bournemouth Airport, an EC135 covers southern counties.

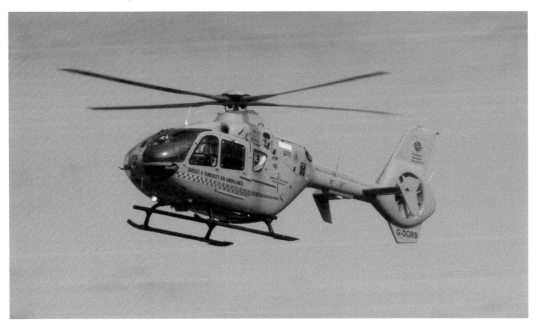

The Dorset & Somerset Air Ambulance is based at Henstridge Airfield on the Dorset/Somerset border. As with the police, their service now overlaps into adjacent counties operating this EC135 in the early 2020s.

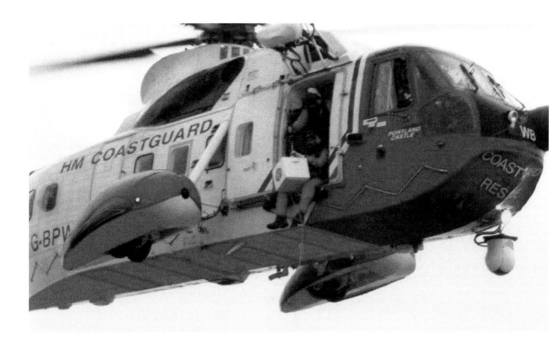

HM Coastguard took over air sea rescue duties at Portland in October 1995 with this Sikorsky S-61 *Portland Castle*. With the closure of the base the service moved to Lee-on-Solent from where Agusta AW189s currently provide cover along the Dorset coast.

RAF Chinooks are also seen frequently over the county. These might be involved in military operations in the Bulbarrow or Bovington areas, undertaking crew training at Bournemouth, or working with the Royal Marines in Poole Bay.

Above: Highly popular air shows were held at Bournemouth Airport in the 1970s/80s. Here Air Cadets watch as B-17 Flying Fortress *Sally B* undertakes its display, during the July 1979 show, while a Fairey Swordfish awaits its turn.

Right: A poster for the 1988 show which featured not only the Red Arrows, but a visit by Concorde – both huge crowd pullers. It later became unpractical to hold shows at the airport due to security reasons and an increase in aircraft movements.

TVS

AIR ★ SHOW SOUTH ★ 88

BOURNEMOUTH INTERNATIONAL AIRPORT 4 - 5 JUNE 1988

In support of the
ROYAL AIR FORCE BENEVOLENT FUND

£2.00

COMPETITION WIN A Canon CAMERA

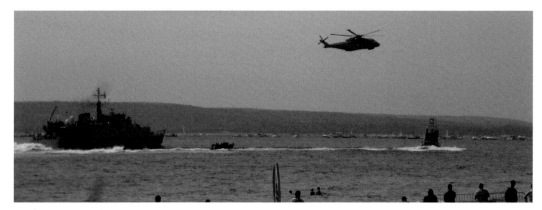

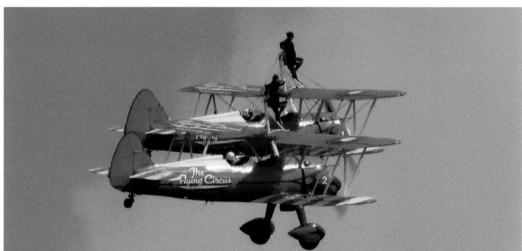

The Bournemouth Air Festival held its first sea front show in 2008 and is now the biggest free display in the country, with all three military services taking part. Under way are a Royal Navy assault on the beach, wing walking on Stearmen biplanes and a fly-past of Second World War fighters.

Right and below: The Red Arrows are regular favourites with their stunning displays around the county. Most popular are their seafront displays at the likes of Lyme Regis, Weymouth, Swanage and Bournemouth. The crews are seen at one of the regular buffets that were laid on in their honour by the Bournemouth Red Arrows Association, which has raised large sums for charity over the years.

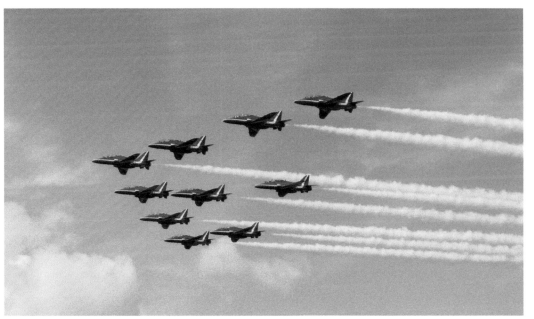

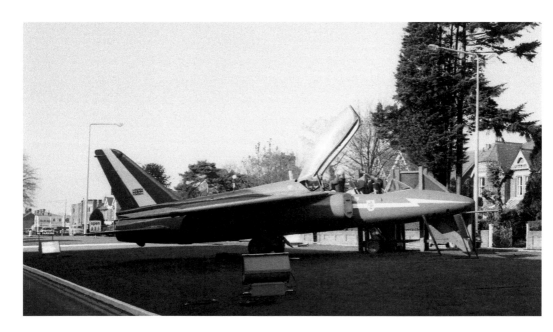

As well as appearing at air shows, the Red Arrows made other appearances. Here a 'retired' Gnat is on display at English's garage in Branksome in November 1969. It was part of a RAF display where two prospective recruits try the cockpit.

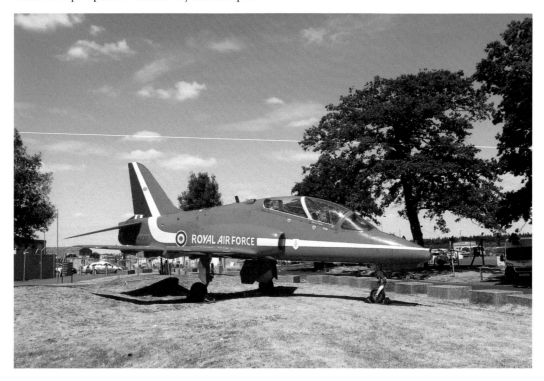

In July 2018 a RAF 100 display was held at Bournemouth by the RCA Group, owners of the airport. Among the displays the main attraction for many was this Red Arrows Hawk positioned outside the Arrivals Terminal for a few months.

Another fund-raising event is the Dorset Plane Pull held at Bournemouth Airport each August bank holiday. Teams see which one can pull a Boeing 737 over 50 metres in the shortest time. Over the years these times have greatly reduced.

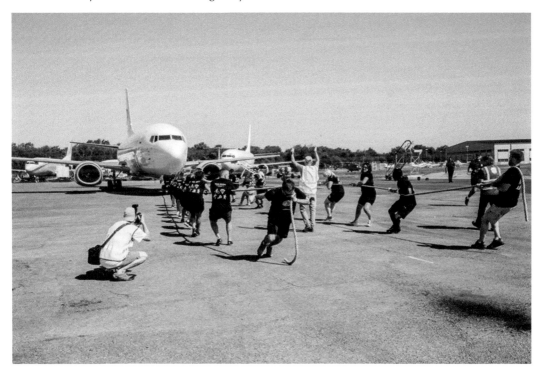

Luckily the Boeing 737 is empty, but teams still need to make an initial effort to get the airliner moving, then it's just a case of keeping the momentum going. Up to 2019 the Dorset Plane Pull events have raised over £170,000 for local charities.

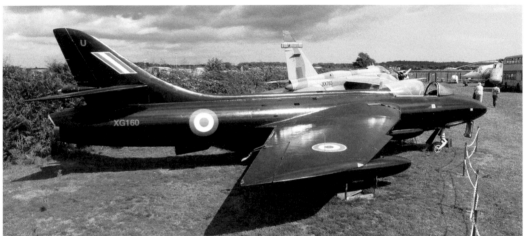

Adjacent to the airport is the Bournemouth Aviation Museum. Originally located on the airport, it moved site in 2008. Visitors can climb into the cockpits of most of the aircraft on display and there are excellent views of activity at the airport.

One of the aircraft on display is this Boeing 737, which was operated by well-known local airline Palmair. As well as holiday flights to the Mediterranean the airline was well known for the large number of day trips it offered from Bournemouth.

As part of its 'hands on' policy the museum's 737 is open to visitors. Inside the cabin storyboards and mementoes cover the history of the airline; Bath Travel and Peter Bath – all well-known names in Bournemouth's history.

Bournemouth Airport's current departure terminal which was opened in June 2010. Passenger numbers have fluctuated over recent years, currently just under 1 million a year, although the terminal is capable of handling 3 million.

The airport still sees diversions from London, as it did in the 1940s/50s. Here a trio of British Airways Boeing 737s are parked outside of the terminal. Although capable of handling more diversions, the problem is transporting passengers on to their final destinations.

Ryanair was the first of the low-cost carriers at Bournemouth, with services to Dublin commencing in 1996. Today the carriers mainly operate flights to the Mediterranean holiday resorts, with further destinations hopefully to be added.

The airport sees aircraft of all different shapes and sizes. Here an Airbus Beluga freighter swallows the fuselage of an Airbus A300. Russian Antonov and Ilyushin freighters also appear when outsize loads need to be carried.

At the other end of the scale is this Diamond Star. From the 2010s a large number have been based at the airport with training schools undertaking commercial pilot training. The airport has proved ideal for such training over the years.

There is still military involvement. For the RAF 100 event in July 2019 there was a RAF Typhoon and private Spitfire. All current military types make use of Bournemouth, mainly on training flights, ranging from Hercules to the latest F-35 Lightning.

For a number of years in the 2010s there were a couple of Boeing 747s at Bournemouth used as executive jets by a Sultan from the Middle East. They always looked impressive on take-offs and landings, not needing the full length of the runway.

There are a number of maintenance and overhaul businesses at the airport. Over the years these have attracted a number of airlines, such as this British Airways Boeing 747, seen in 2019. There are also an increasing number of executive jets.